LINE BY LINE YORKSHIRE

NEIL GIBSON

AMBERLEY

I would like to dedicate this book to my dear brother Geoff, who started me off on this crazy hobby, and to all the friends I've travelled with along the way.

First published 2022

Amberley Publishing
The Hill, Stroud
Gloucestershire, GL5 4EP

www.amberley-books.com

Copyright © Neil Gibson, 2022

The right of Neil Gibson to be identified as the Author of this work has been asserted in accordance with the Copyrights, Designs and Patents Act 1988.

ISBN 978 1 3981 0472 3 (print)
ISBN 978 1 3981 0473 0 (ebook)

British Library Cataloguing in Publication Data.
A catalogue record for this book is available from the British Library.

Typesetting by SJmagic DESIGN SERVICES, India.
Printed in Great Britain.

Introduction

Welcome to the second book in my line-by-line series, covering my travels around the railways of Yorkshire between 2000 and early 2022. With the railway scene constantly evolving, I have tried to showcase as many locations, traction types and liveries as I could fit in. It has taken quite a while to put together as I have a large selection of images of local railways and I am not the most decisive of people.

I was born in Doncaster in the 1970s and grew up with an older brother, Geoff, who had an interest in railways and worked at 'The Plant'. Early railway memories centre around Doncaster and York often including riding behind the mighty Deltics. As I got older, we began to explore much of the UK by rail and my interest in photography was born.

Early cameras were handed down from my brother, along with the advice to always use slide film. I can recall two different Minolta's before moving on to a Canon A1 and then many Canon EOS3s (I still have three in a drawer) until moving on to digital full time in 2010. I started my digital adventure with a Canon 400D, which was used in a frame alongside the EOS3 taking slides. Once the decision to go digital full time was made, I upgraded to a Canon 5D mk2 and finally moved on to the mk3, which I still use today. The vast majority of my images are taken using a 50-mm standard lens but I also carry a 24–105-mm zoom along with 85-mm and 100-mm primes. The biggest change to my photography approach came in September 2014 when I began

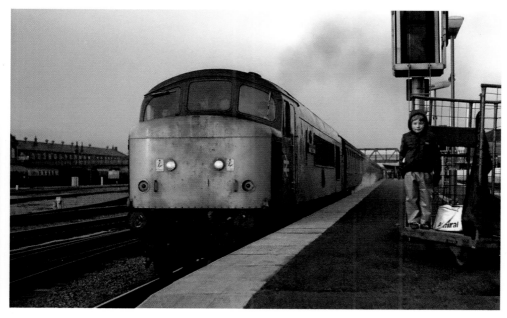

46026 and the author, age six, February 1981.

to experiment with using a pole and tablet connected via Wi-Fi to remotely operate the camera. I appreciate there are many different views on the use of poles and whilst I find it to be a pain to set up and operate on occasions, the many new vantage points that are available more than make up for the niggles.

I regularly go through various websites to highlight potential opportunities to head off around the country chasing rail tours and land cruises, as well as keeping up to date with changes in workings and motive power. A photography trip will often start with phone calls between friends to see who is available, who can drive and what may be included in the itinerary. Planning and research can be extremely thorough, consulting previous images, OS maps and more recently utilising Google Earth and sun angle apps.

In 2007 I created my website 'Travels with the Railway Obsessive' to share my results, the title being the perfect description for my interaction with the hobby of railway photography. I travel the length and breadth of the UK, often getting up at silly o'clock in search of the perfect image. When a planned trip leads to a great result there is no better feeling. I also enjoy the days out, visiting interesting and spectacular parts of the country, often in the company of good friends and, over the past eight years, my cocker spaniel Holly (who even makes an appearance in one of the images).

Neil Gibson
May 2022

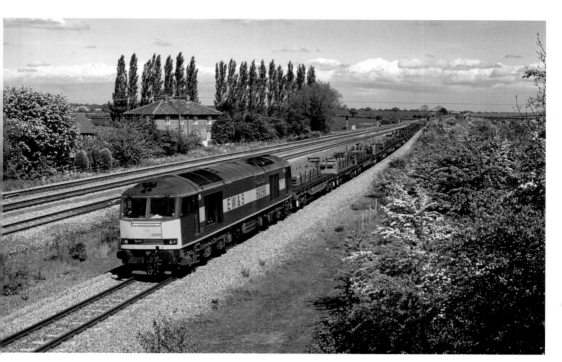

60098 *Charles Frances Brush* passes Bolton Percy on 6V40 06.02 Lackenby–Llanwern steel slabs, 11 May 2002.

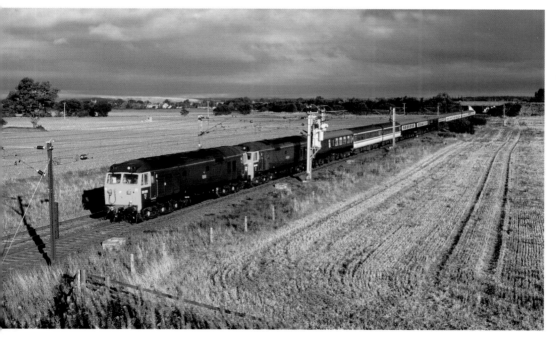

50031 and 50049 race south past Thorpe Willoughby on 1Z55 08.09 York–Finsbury Park 'Countryside Alliance' charter, 22 September 2002.

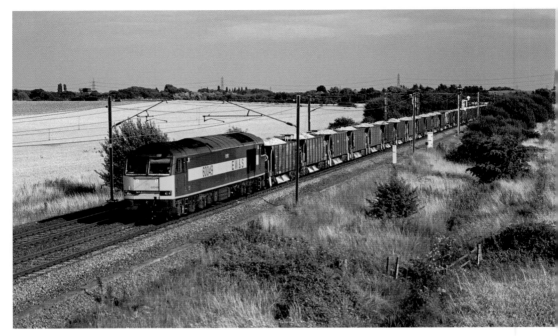

60049 passes Burn on a glorious Sunday afternoon with an unknown engineers working, 3 August 2003.

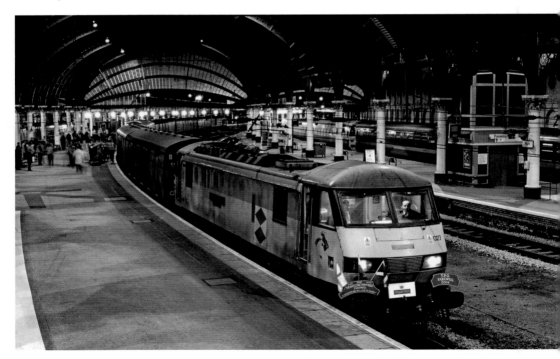

90027 stands at York station on 1E94 22.15 Bristol–Low Fell TPO, 10 January 2004. This was the very last NB cross-country TPO working, hence the headboards.

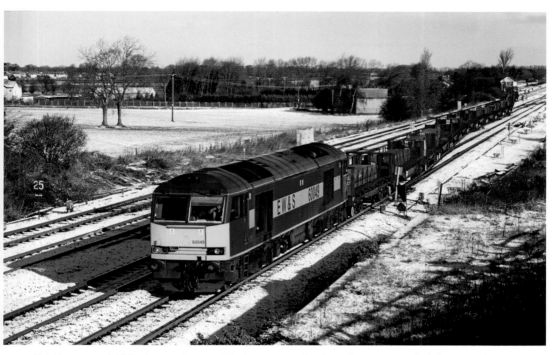

60049 crosses Milford Junction on 6V40 06.02 Lackenby–Llanwern steel slabs, 27 February 2004.

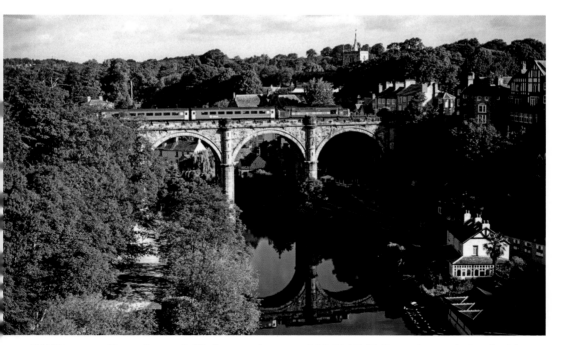

37408 crosses Knaresborough Viaduct on the rear of 2C67 07.58 Knaresborough–Leeds, 28 June 2004.

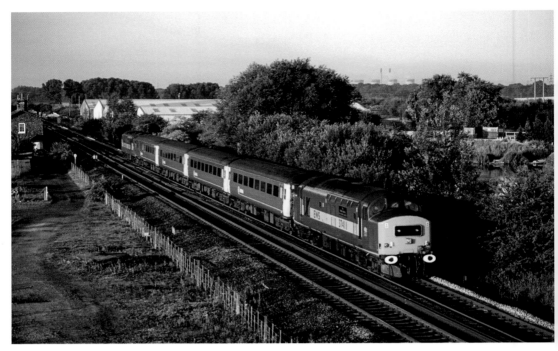

37411 nears Sherburn-in-Elmet on 5C67 06.12 Knottingley–Knaresborough ECS, 19 July 2004.

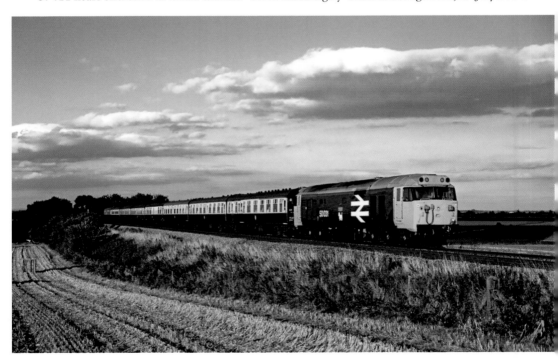

50031 passes Barkston Ash on 1Z40 09.48 Inverness–Birmingham International charter, 28 August 2005.

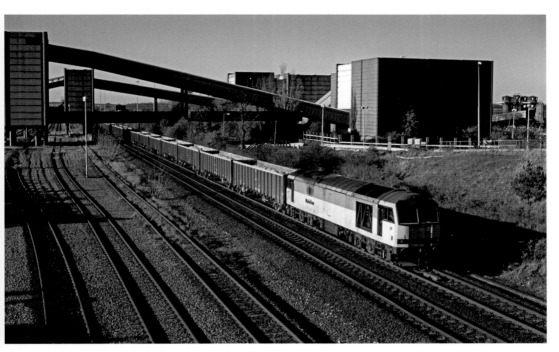

60077 passes the Gascoigne Wood pit complex on 6Z48 08.47 Rylstone–Hull Dairycoates stone, 17 May 2005.

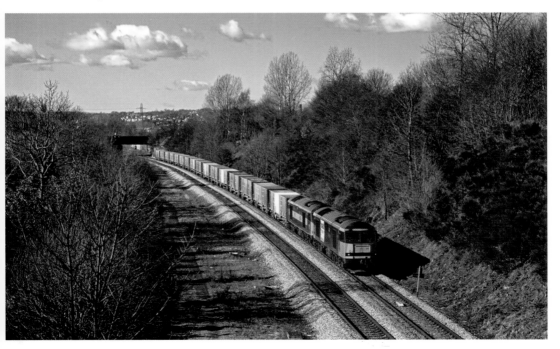

60059 leads failed 60008 past Dewsbury on 6E06 10.00 Bredbury–Roxby 'binliner', 1 March 2006.

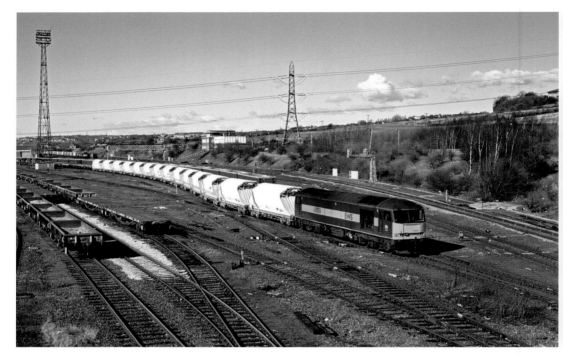

60058 stands in Healey Mills yard awaiting departure on 6D72 Healey Mills–Rylstone 'Tilcon' stone train, 1 March 2006.

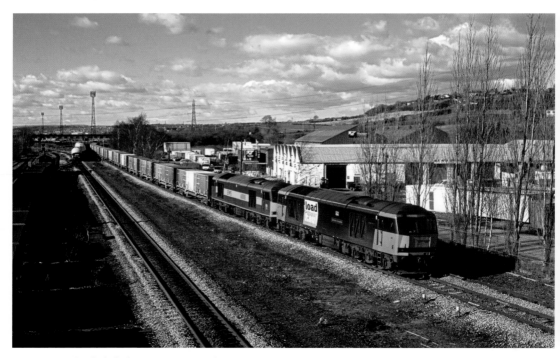

60059 leads failed 60008 past Horbury on 6E06 10.00 Bredbury-Roxby 'binliner', 1 March 2006.

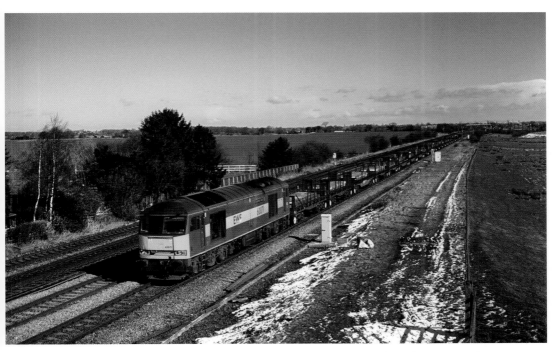

60071 passes a chilly Colton on 6V36 08.17 Lackenby–Margam steel working, 4 March 2006.

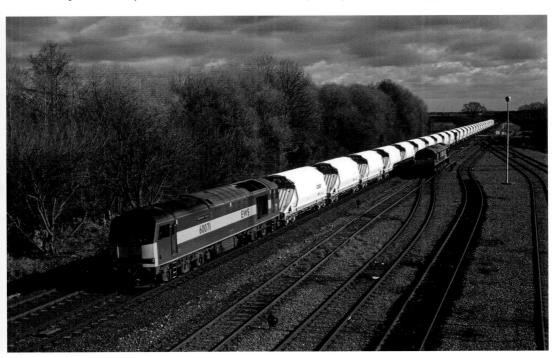

60071 nears Gascoigne Wood under a very moody sky on 6D72 11.33 Hull Dairycoates–Rylstone 'Tilcon' empty stone, 18 March 2006.

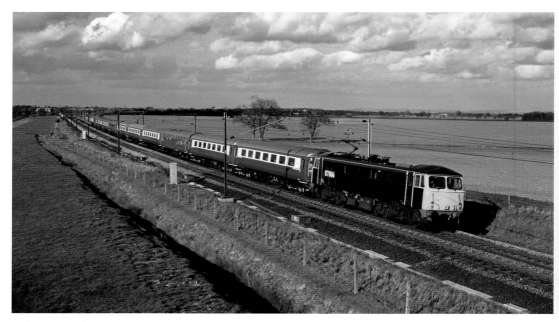

All-over blue (ex-GBRF)-liveried 87006 passes the gallery at Colton on 1Z28 08.20 Edinburgh–LKX 'Blue Pullman' charter, 17 April 2006.

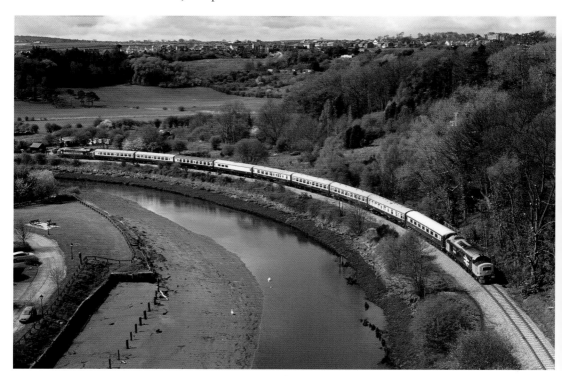

Large logo-liveried 37425 nears Whitby passing Larpool Viaduct on 1Z47 05.36 Rugby–Whitby Kingfisher Tours 'The Whitby Jet' charter, 29 April 2006.

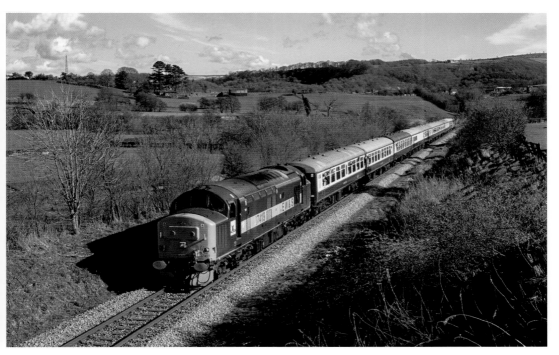

37419 passes Glaisdale on 1Z45 16.36 Whitby–Rugby Kingfisher Tours 'The Whitby Jet' charter, 29 April 2006.

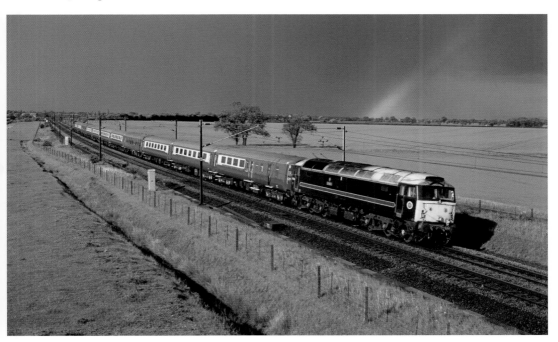

Fragonset-liveried 47703 Hermes heads south away from the storm past Colton on 1Z23 17.47 York–LKX 'Blue Pullman' charter, 18 May 2006.

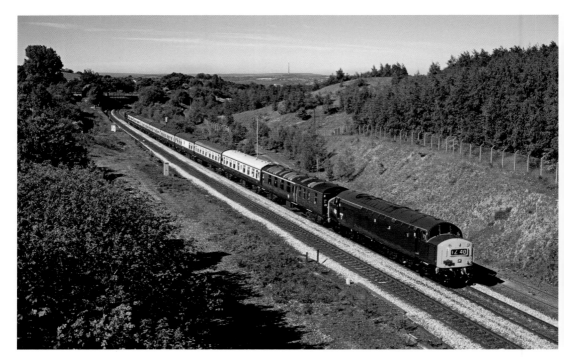

Immaculately turned-out 40145 passes Welbeck on 1Z40 06.37 Crewe–Whitby Pathfinders 'Esk Invader' charter, 3 June 2006.

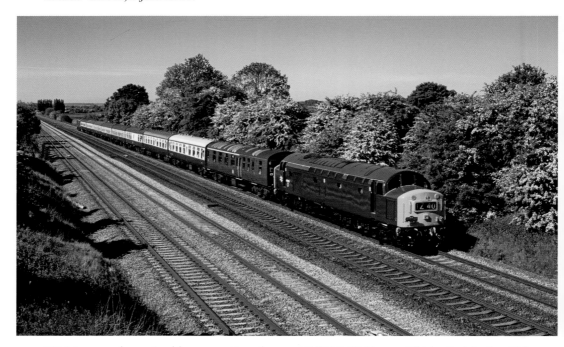

40145 passes the spring blossom at Brumber on 1Z40 06.37 Crewe–Whitby Pathfinders 'Esk Invader' charter, 3 June 2006.

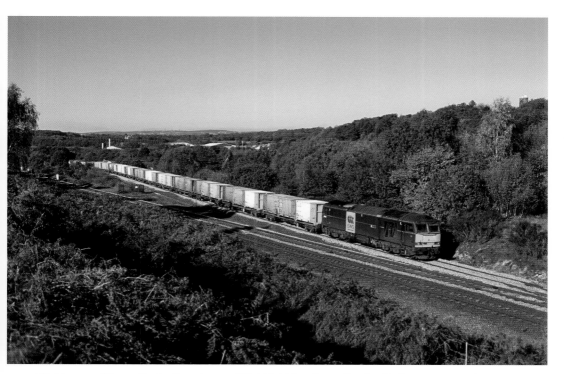

60044 passes Heaton Lodge Junction on 6E06 10.00 Bredbury–Roxby 'binliner', 2 November 2006.

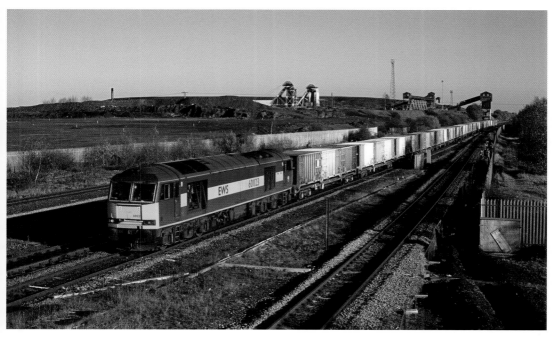

60023 passes Hatfield & Stainforth station on 6M05 09.30 Roxby–Northenden 'binliner', 23 November 2006.

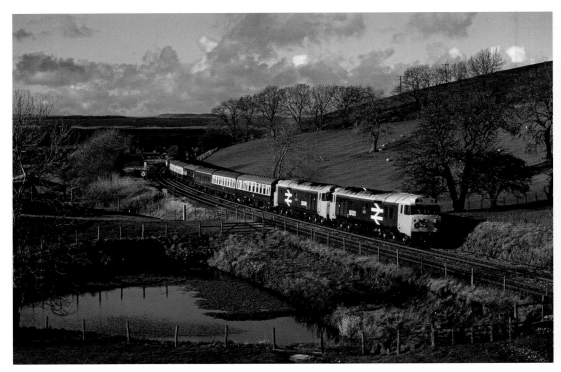

50031 and 50049 head away from Hellifield on 1Z50 05.45 Cardiff–Leeds 'The Airean Raider' charter, 16 December 2006.

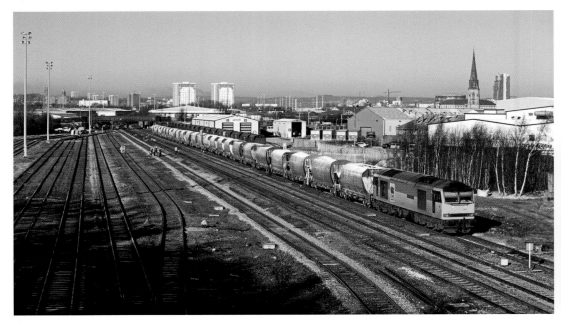

60046 sets off from Stourton on 6M17 10.20 Leeds–Peak Forest stone empties, 7 February 2007.

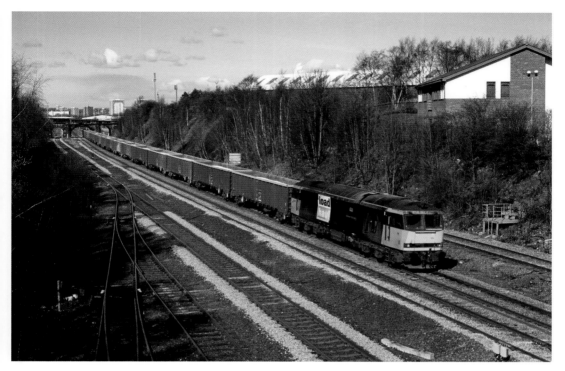

60059 passes Stourton on 6D48 09.15 Rylstone–Dewsbury stone, 21 March 2007.

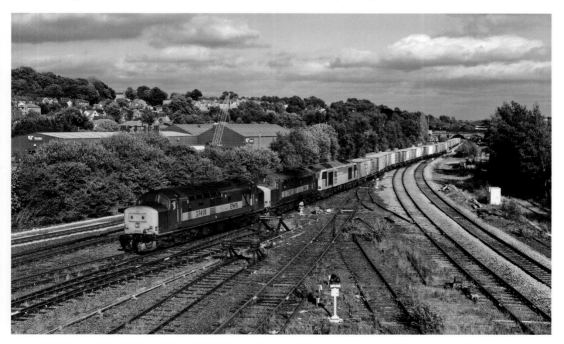

37410 and 37422 drag failed 60095 into Healy Mills on a delayed 6M05 Roxby–Northenden 'binliner', 11 July 2007.

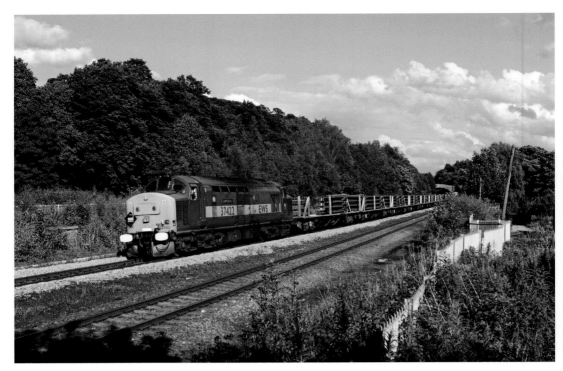

37422 passes Horbury on 6M02 15.00 Scunthorpe–Crewe rail train, 18 July 2007.

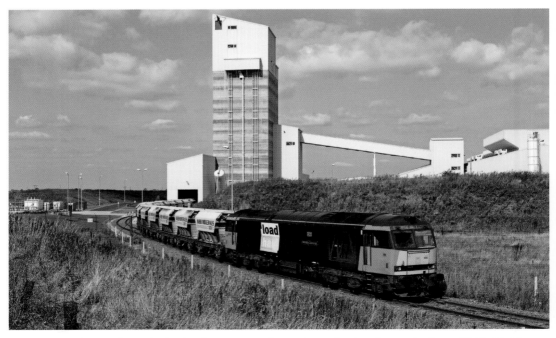

60059 shunts through the loader at 'Guardian Glass' Goole after arrival on 6H92 04.00 Peterborough–Goole loaded WBB sand, 11 September 2007.

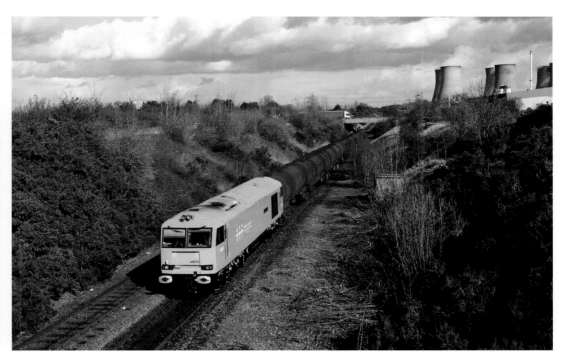

On its first working after being repainted into 'Teenage Cancer Trust' powder blue livery, 60074 passes High Eggborough on 6D42 11.35 Eggborough PS–Lindsey empty tanks, 3 March 2008.

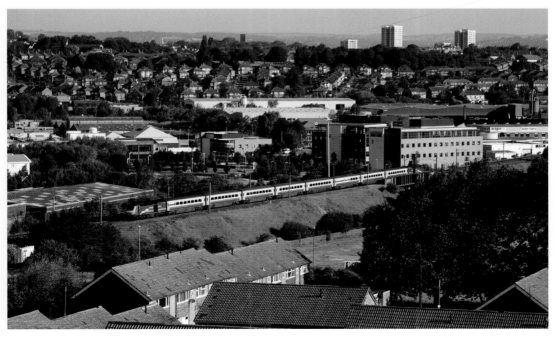

43075 passes Elland Road shortly after departure on 1C17 07.25 Leeds–London St Pancras, 4 July 2008.

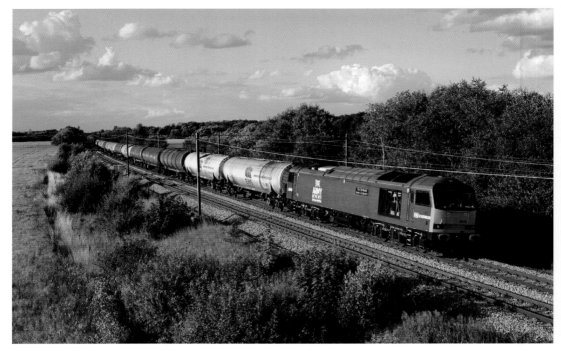

Freshly repainted into DB/Territorial Army livery, 60040 passes Bishop Wood on 6D43 13.51 Jarrow–Lindsey empty tanks, 1 August 2008.

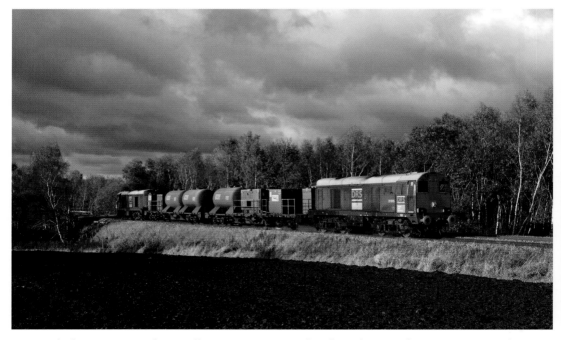

With the sprayers working well, 20305 passes Wombwell on the rear of 3S14 11.14 Grimsby–Malton RHTT, 31 October 2008.

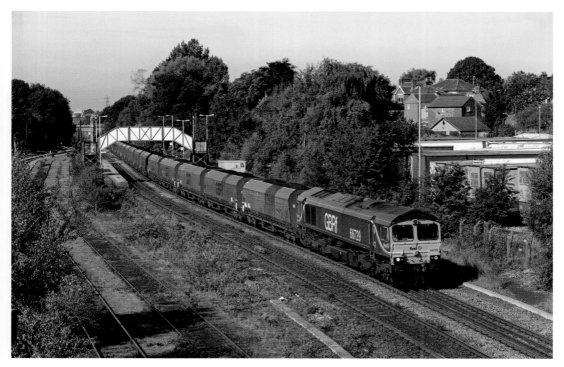

66729 passes Knottingley station on 6H20 07.47 Redcar–Drax PS coal, 11 September 2009.

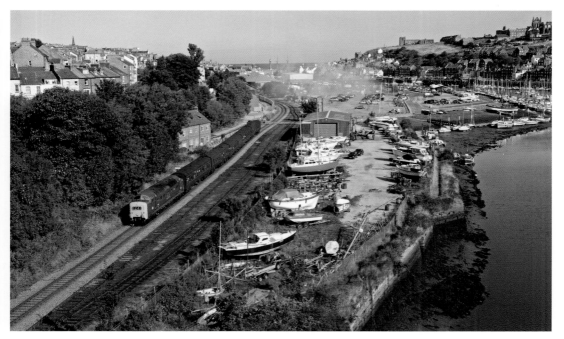

After a brisk run round 55022 roars away from Whitby on 1Z51 10.45 Whitby–Battersby, 20 September 2009.

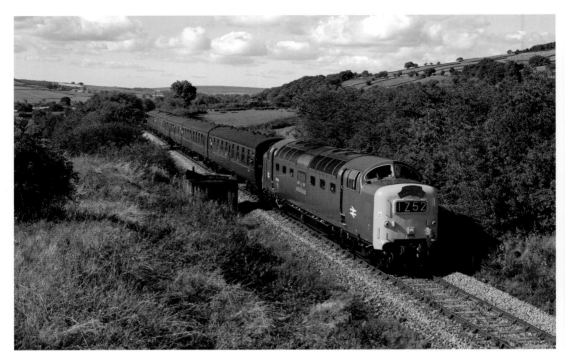

Carrying 'The Hull Executive' headboard, 55022 passes Houlsyke on 1Z52 12.20 Battersby–Whitby, 20 September 2009.

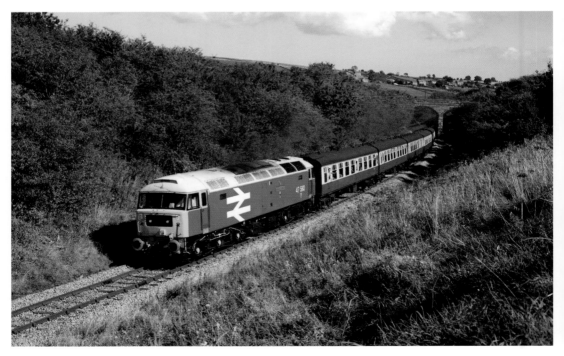

47580 passes Lealholm on 1Z43 12.20 Whitby–Battersby, 20 September 2009.

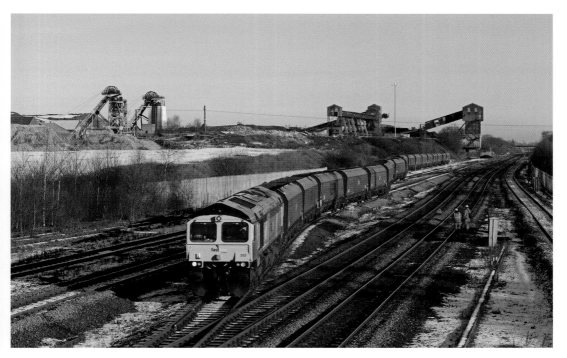

Fastline-operated 66305 snakes across to Hatfield and Stainforth station on 6A59 12.02 Hatfield Colliery–Ratcliffe PS coal, 4 January 2010.

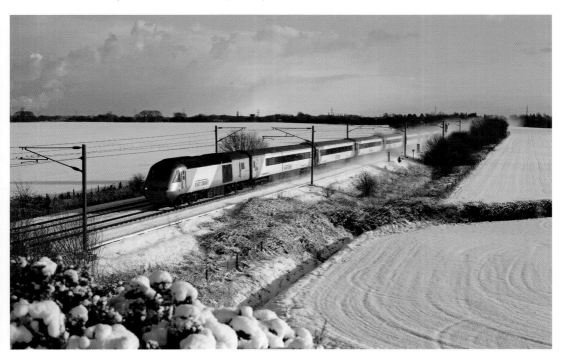

43311 kicks up the snow passing Burn on 1S12 10.30 LKX–Aberdeen, 6 January 2010.

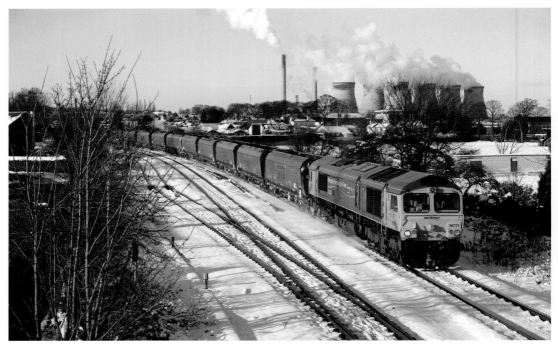

66721 passes a frozen Knottingley on 6H93 07.35 Tyne Dock–Drax PS coal, 8 January 2010.

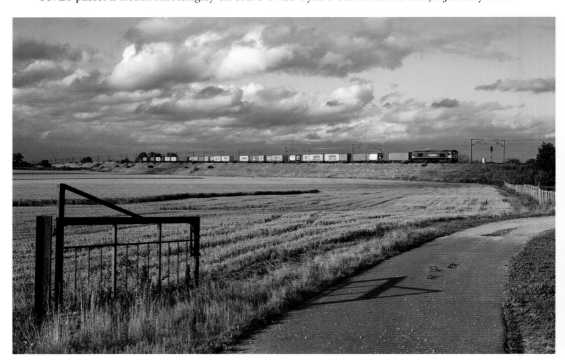

Under a threatening sky 66536 passes Little Heck on 4L79 15.45 Wilton–Felixstowe liner, 20 August 2010.

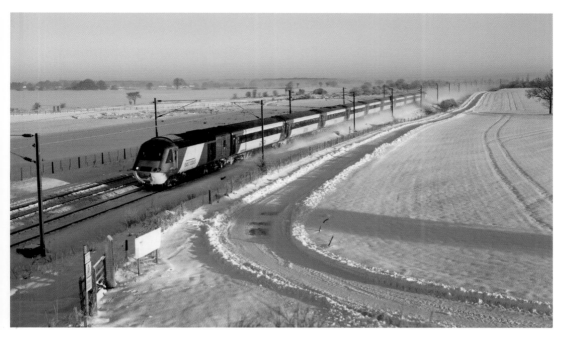

43319 passes Colton on 1F53 07.00 Newcastle–LKX, 3 December 2010.

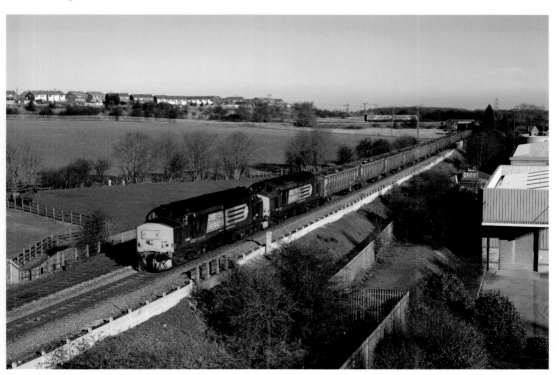

37688 and 37510 pass Ferrybridge on 6Z50 09.25 Stockton–Sheerness loaded scrap, 3 February 2011.

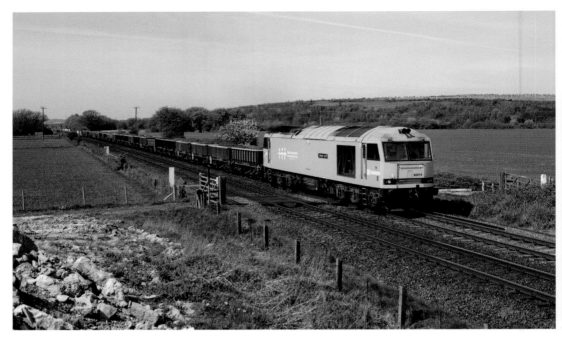

60074 passes the Hambleton 'muck stack' on 6T56 11.00 Keighley–Doncaster spent ballast, 17 April 2011.

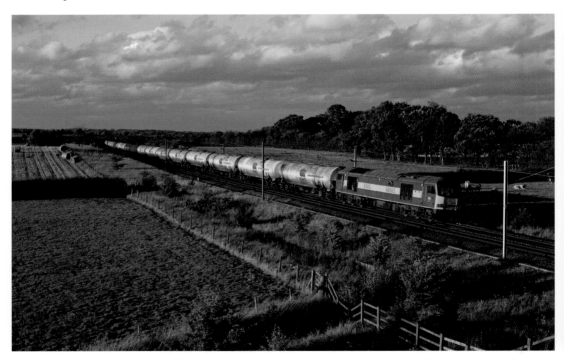

60065 powers past Bridge 33, Colton, on 6D43 13.50 Jarrow–Lindsey empty tanks, 6 September 2011.

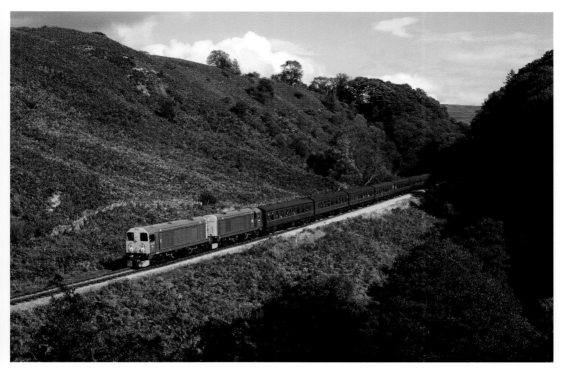

20107 and 20096 look superb as they pass Thomason Foss on the 13.00 Pickering–Grosmont, 17 September 2011.

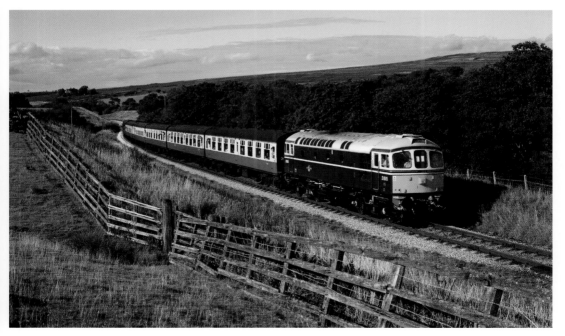

D6515 passes Sadlers House on the 15.30 Grosmont–Pickering, 17 September 2011.

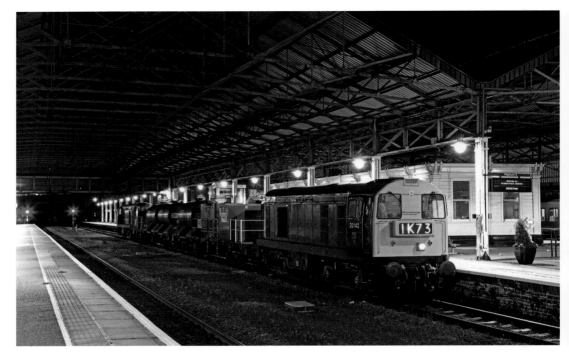

20142 stands at Huddersfield while changing ends on 3S23 22.45 Hall Royd Junction–Ilkley RHTT, 5 October 2011.

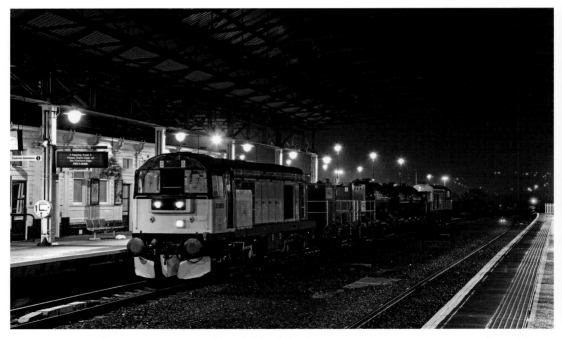

20905 stands at a very wet Huddersfield while changing ends on 3S23 22.45 Hall Royd Junction–Ilkley RHTT, 10 October 2011.

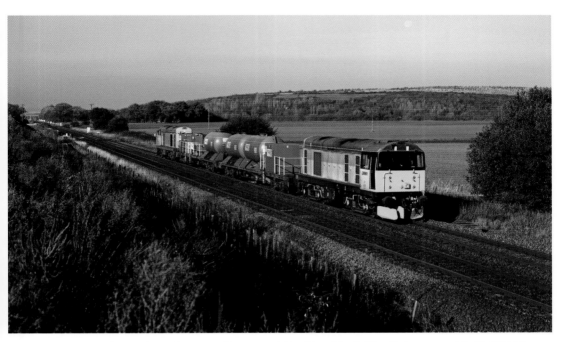

20901 passes the muck stack at Hambleton on 3S27 09.56 York Thrall–Doncaster TMD RHTT, 15 October 2011.

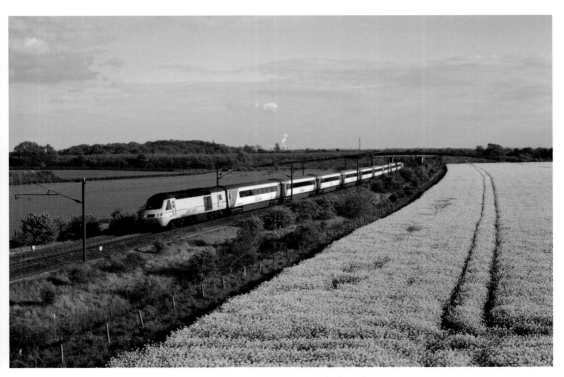

43315 passes Bridge 33, Colton, on 1S25 16.30 LKX–Edinburgh, 15 May 2012.

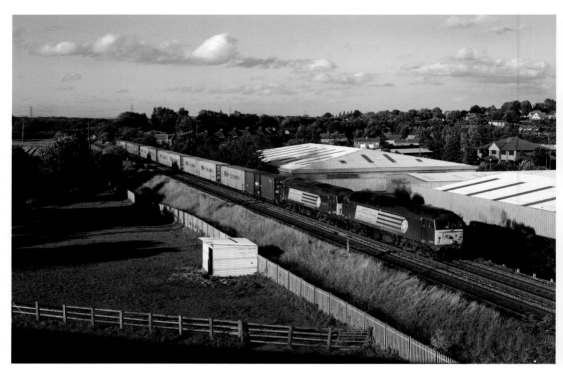

57007 and 57008 pass Knottingley on 4M51 16.10 Tees Dock–Ditton intermodal, 18 July 2012.

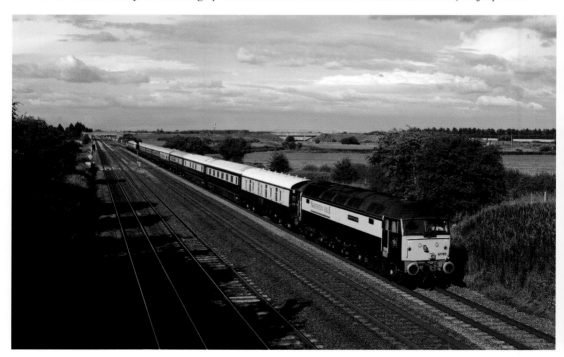

47790 passes Brumber on 1Z45 08.20 Inverness–LKX 'Northern Belle', 6 August 2012.

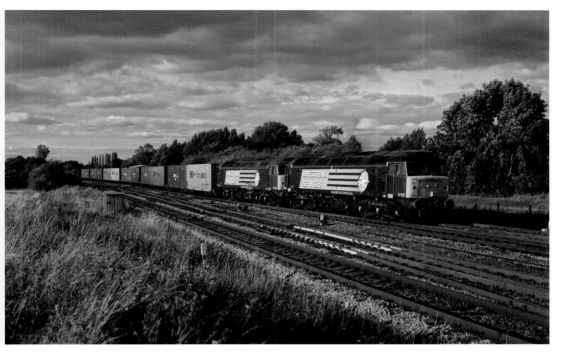

57002 and 57004 cross Milford Junction on 4M51 16.10 Tees Dock–Ditton intermodal,
6 August 2012.

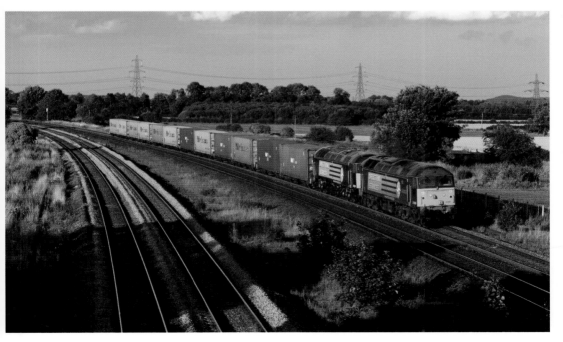

57008 and 57009 pass Burton Salmon on 4M51 16.10 Tees Dock–Ditton intermodal,
8 August 2012.

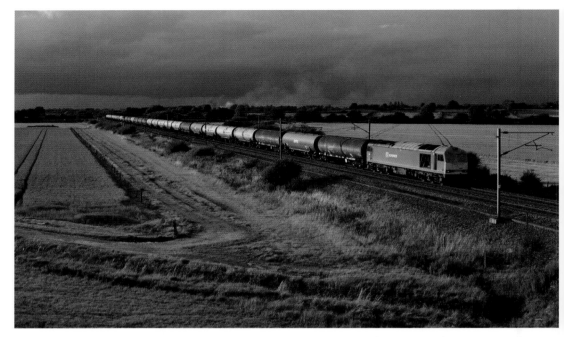

60091 catches a lucky burst of sun passing Burn on 6D43 14.42 Jarrow–Lindsey empty tanks, 21 August 2012.

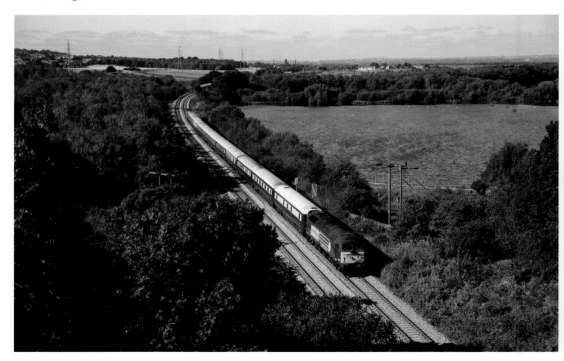

47818 passes Fairburn Ings on 1Z54 08.00 Crewe–Harrogate 'Northern Belle', 15 September 2012.

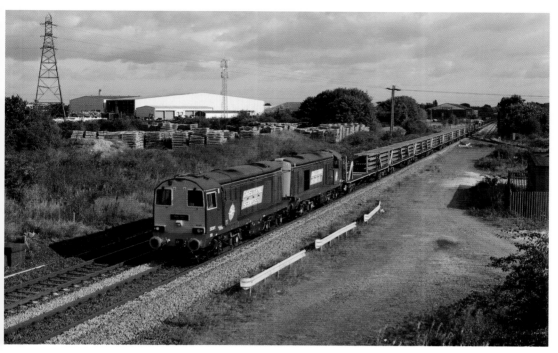

20301 and 20302 pass Kirk Sandall on 6G20 09.19 Scunthorpe Trent Yard–Doncaster Up Decoy rails, 29 September 2012.

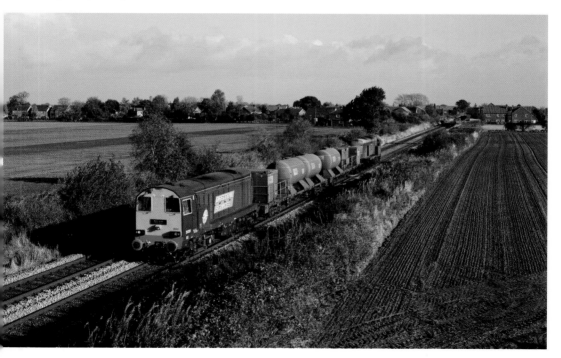

20301 passes Cliffe on 3S14 11.03 Stocksbridge–York Thrall RHTT, 27 October 2012.

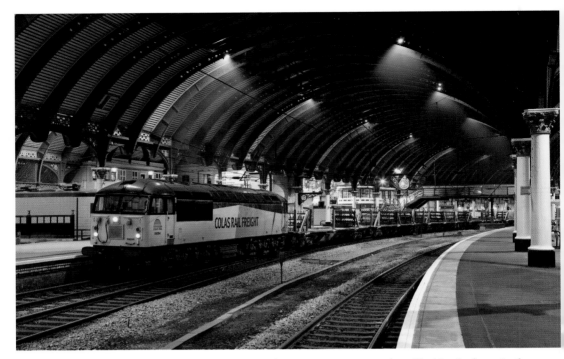

With the clock showing 04.20 on 18 December 2012, 56094 stands at York's platform 3 after a late arrival on 6C71 22.40 Doncaster Up Decoy–York engineers/rail drop. The rails were dropped roughly where the train is to replace the length of platform 3.

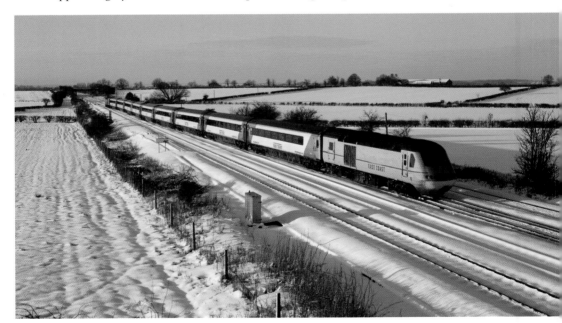

43274 crosses a snowy Colton South Junction at the rear of the diverted 1E03 06.20 Edinburgh–LKX, 26 January 2013.

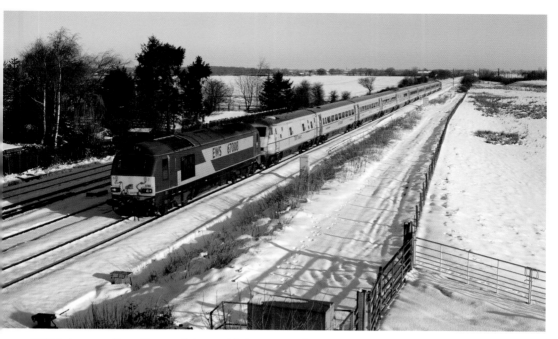

67008 drags an East Coast mk4 set with 91101 on the rear past Colton on the diverted 1E05 07.30 Edinburgh–LKX, 26 January 2013.

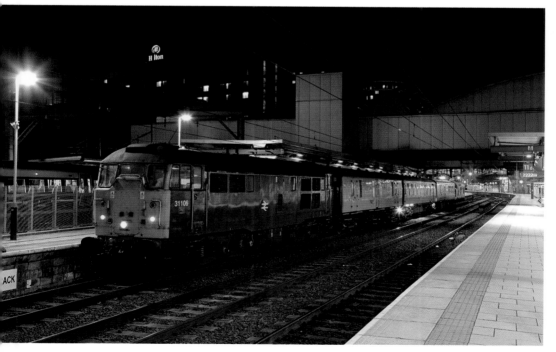

BR Blue-liveried 31106 stands at Leeds on 3Q28 22.06 Neville Hill–Derby RTC test train, 6 February 2013.

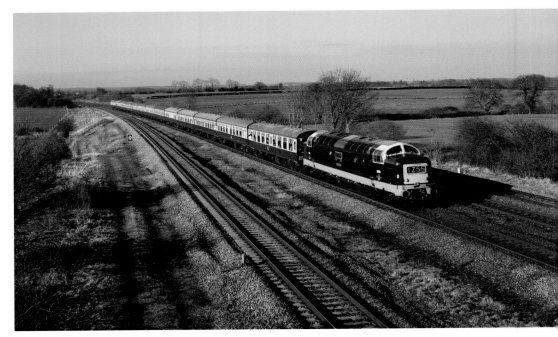

D9009 (55009) *ALYCIDON* races north past Bolton Percy on 1Z55 06.03 Crewe–Edinburgh Pathfinder Tour 'Eidyn Burgh Scot' charter, 6 April 2013.

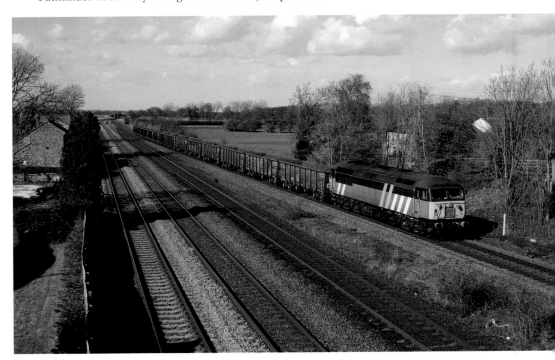

DCR operated but still carrying unbranded Fastline livery, 56301 passes Ulleskelf on 6Z20 16.59 York Holgate–Kellingley colliery empty coal, 29 April 2013.

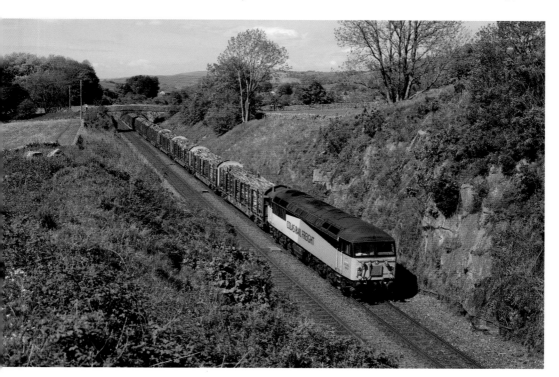

56302 heads south from Settle on 6Z70 15.30 FO Ribblehead–Chirk logs, 31 May 2013.

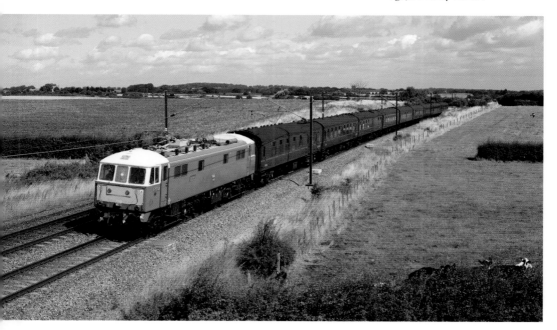

Electric blue 86259 *Les Ross* passes Bridge 33, Colton, on 1Z86 07.18 Edinburgh–LKX charter, 3 August 2013. The train had been delayed north of York after a bird strike broke the middle windscreen.

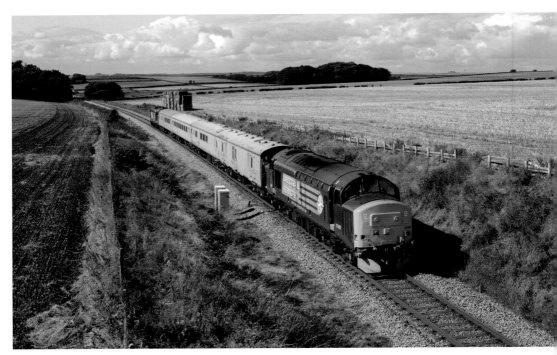

37402 passes Reighton on 1Q13 12.22 Scarborough–Derby RTC via Hull test train, 14 September 2013.

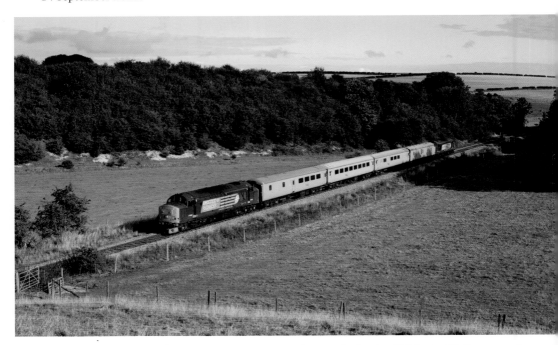

37688 nears Hunmanby on 1Q13 12.22 Scarborough–Derby RTC via Hull test train, 14 September 2013.

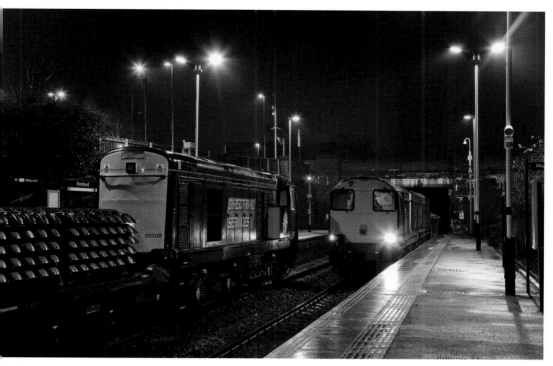

20308, 20303 and 20312 stand at Wombwell station during an engineering possession, 21 January 2014.

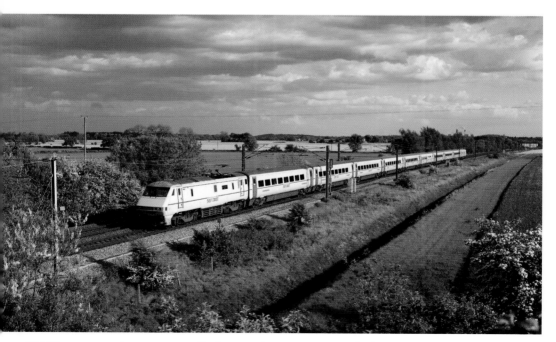

91107 passes a rather overgrown Ryther on 1S25 16.30 LKX–Edinburgh, 14 May 2014.

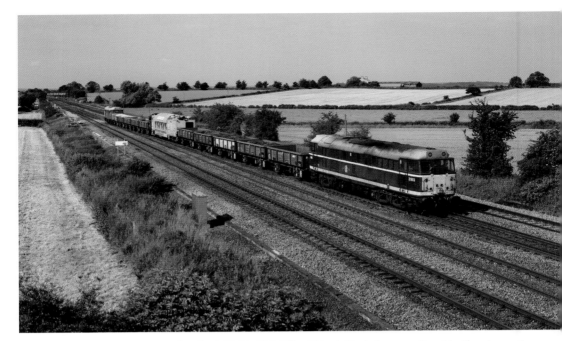

31190 and 31601 top-and-tail 6Z42 08.40 Milford Yard–York Leeman Road 'railvac' crossing Colton South Junction, 22 June 2014.

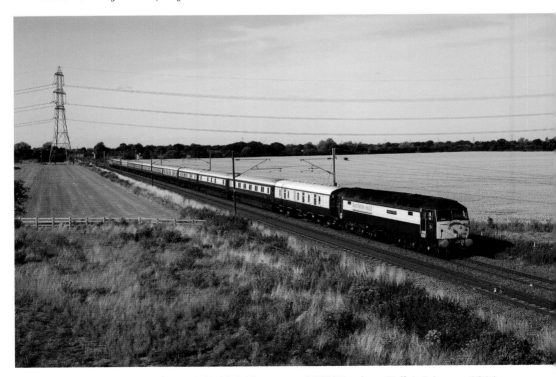

47790 passes Joan Croft on 1Z22 08.56 Inverness–LKX 'Northern Belle', 4 August 2014.

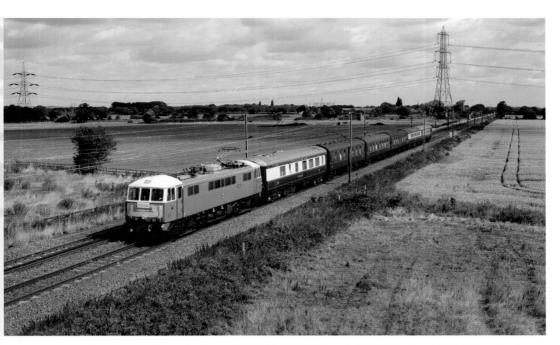

86259 *Les Ross* passes Joan Croft on 1Z05 07.18 Edinburgh–LKX 'Prudential Ride London' charter, 9 August 2014.

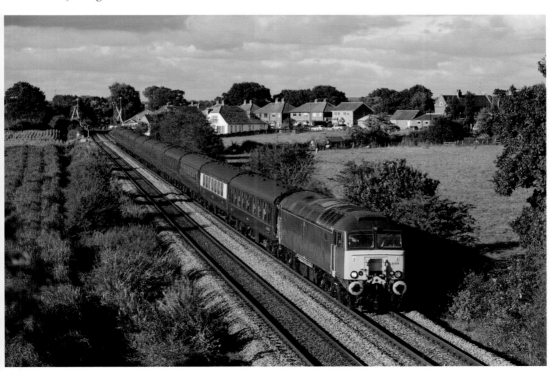

57316 passes Haxby on 1T39 17.00 Scarborough–York 'Seaside Express', 26 August 2014.

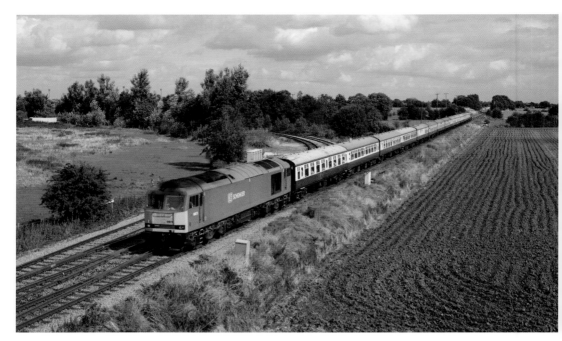

60079 passes Whitley Bridge Junction on 1Z41 14.04 Drax PS–Monk Bretton 'Drax 40' charter, 30 August 2014.

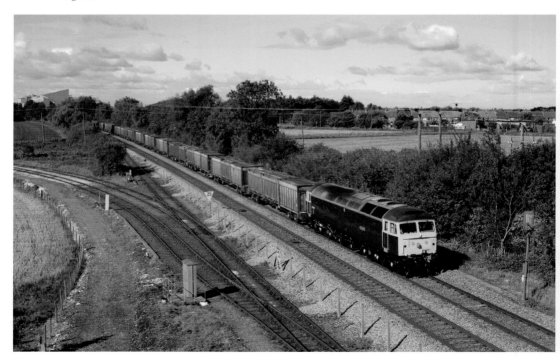

Looking splendid in the late September sunshine, 47843 passes Barlby, Selby bypass, on 4D94 10.20 Doncaster Down Decoy–Hull CT gypsum, 24 September 2014.

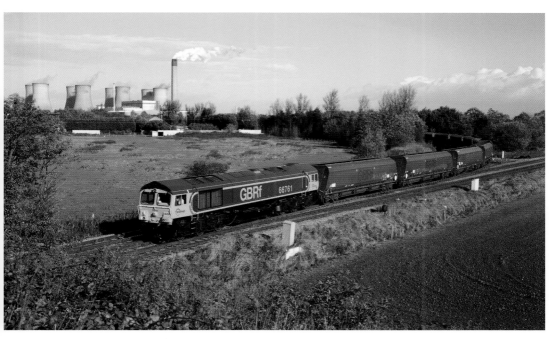

Straight out of the box, 66761 crosses Whitley Bridge Junction on 4D79 14.24 Eggborough PS–Doncaster Down Decoy empty coal, 21 October 2014.

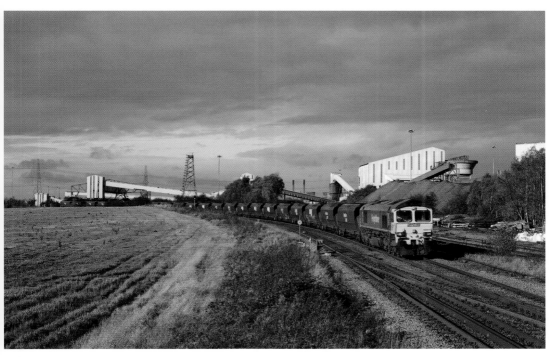

With Kellingley Colliery forming the backdrop, 66514 nears Sudforth Lane on 6R08 08.12 Immingham–Drax PS coal, 25 October 2014.

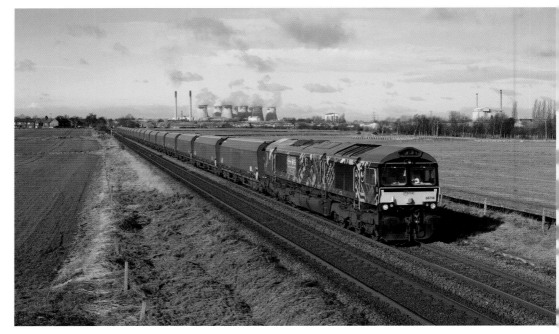

London Underground black-liveried 66718 passes Blackburn Lane, Knottingley, on 6H85 07.11 Tyne Dock–Drax PS, 21 February 2015.

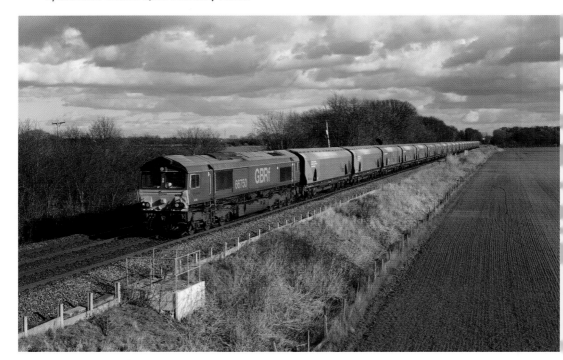

Unique GBRF light blue-liveried 66750 passes Heck Ings on 4N30 14.27 Drax PS–Tyne Dock empty coal, 21 February 2015.

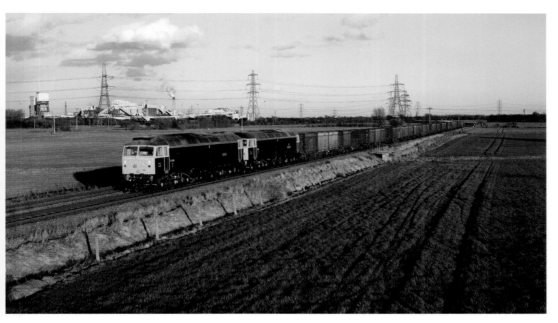

47843 and 47815 pass Blackburn Lane, Knottingley, on 4D31 16.12 Drax PS–Doncaster Down Decoy gypsum, 3 March 2015.

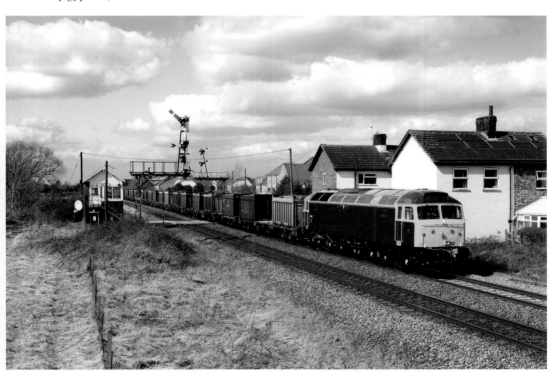

47812 passes Welton signal box on 4D94 10.36 Doncaster Down Decoy–Hull CT empty gypsum, 27 March 2015.

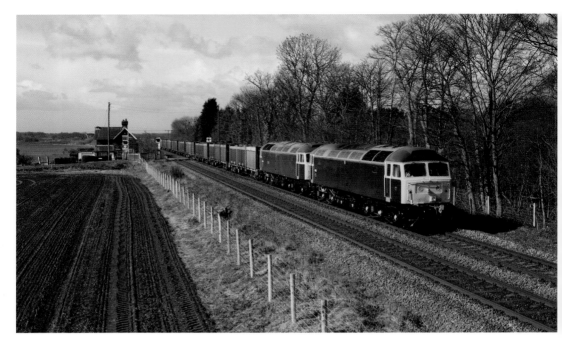

47812 and 47843 pass West Bank on 4D93 09.41 Doncaster Down Decoy–Drax PS gypsum, 1 April 2015.

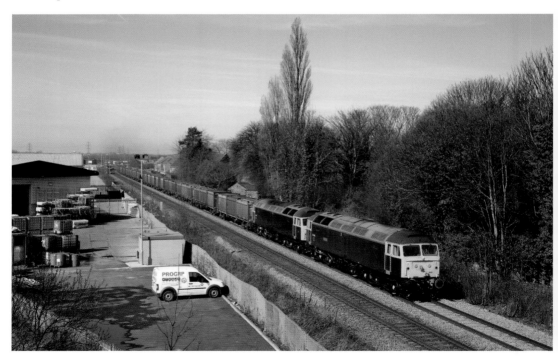

47843 and 47812 pass Whitley Bridge on the late-running 4D93 09.40 Doncaster Roberts Road–Drax PS gypsum, 6 April 2015.

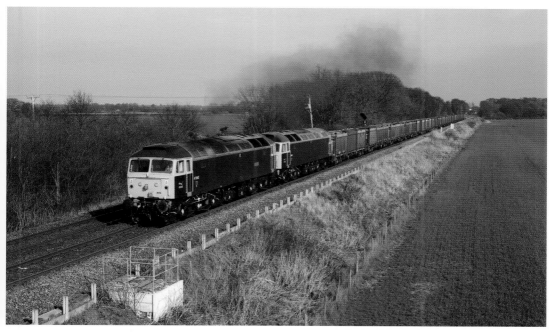

47843 and 47812 apply the power passing Heck Ings on 4D31 16.12 Drax PS–Doncaster Down Decoy gypsum, 6 April 2015.

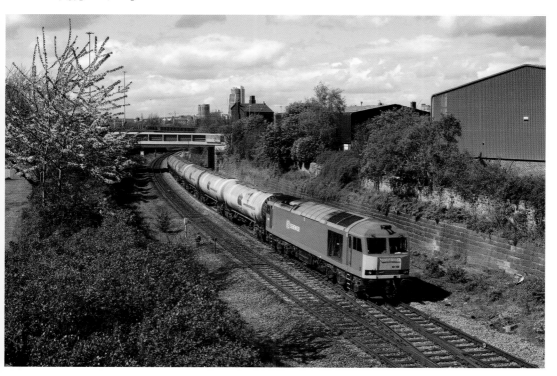

60100 passes Hunslet on 6D80 14.05 Neville Hill–Lindsey empty tanks, 29 April 2015.

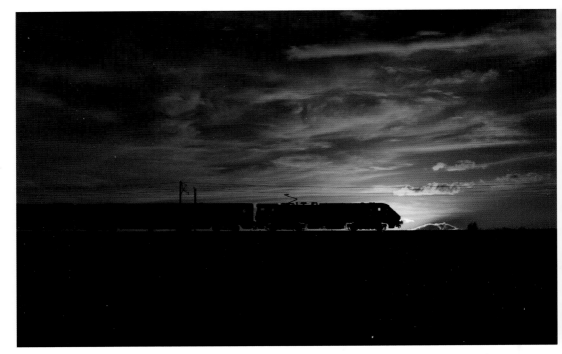

An unidentified Class 91 is silhouetted against the setting sun as it races north past Heck Ings on 1E24 17.00 Edinburgh–LKX, 28 August 2015.

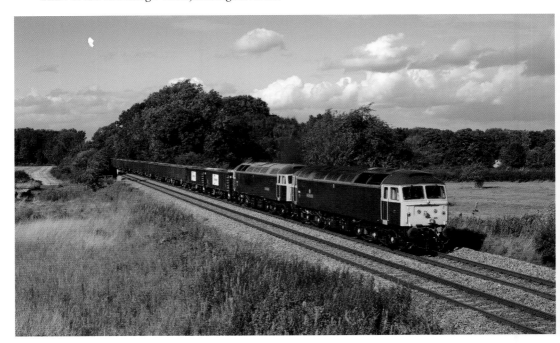

47815 and 47848 pass Walden Stubbs on 6Z47 13.15 Hexthorpe Yard–Hexthorpe Yard crew trainer, 24 September 2015.

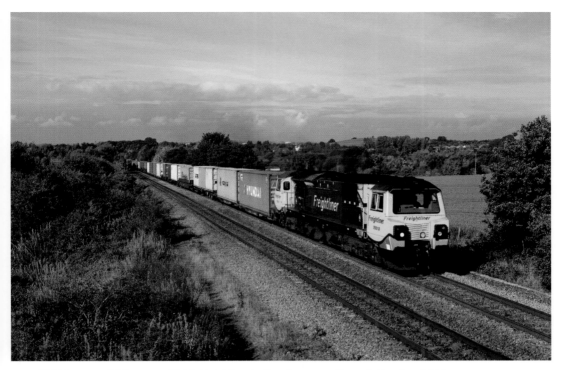

70018 passes Walton on 4O55 12.12 Leeds–Southampton liner, 9 October 2015.

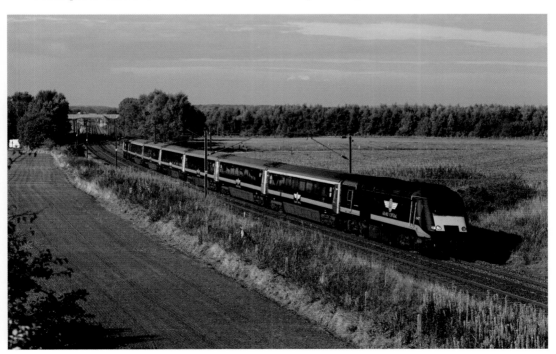

43467 passes Gateforth on 1A65 12.28 Sunderland–LKX, 9 October 2015.

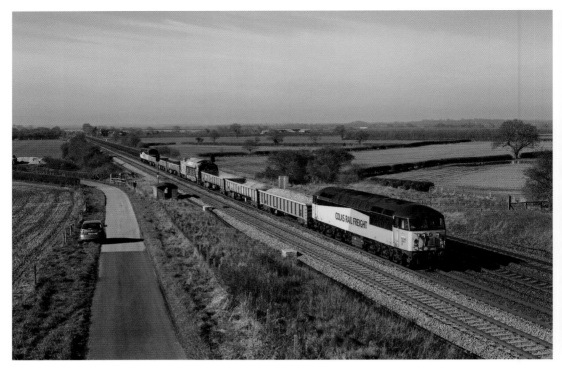

56113 passes the gallery at Brumber on 6C52 08.30 Ferrybridge North Junction–Tyne Yard 'railvac', 10 April 2016.

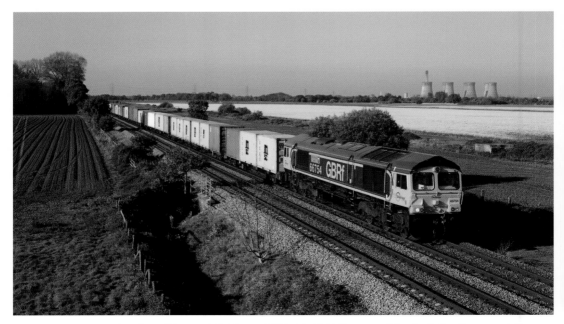

66754 passes the site of Burn airfield on 4Z78 01.58 Felixstowe North–Selby 'intermodal', 17 May 2016.

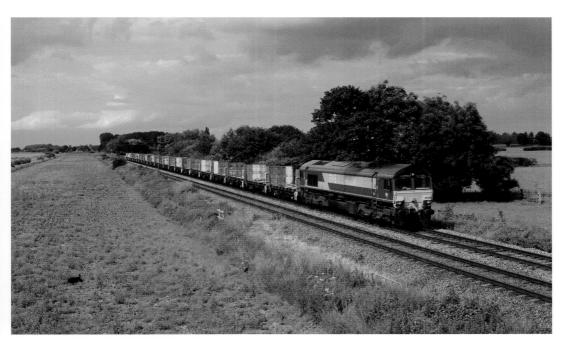

With Holly dog totally ignoring the train, 66200 passes Burn airfield on 4D56 SO 11.32 Biggleswade–Heck empty 'Plasmor' blocks, 25 June 2016.

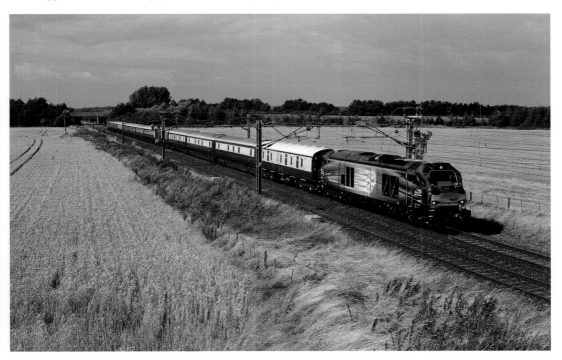

68022 races south past Thorpe Willoughby on 1Z74 11.09 Edinburgh–LKX 'Northern Belle', 8 August 2016.

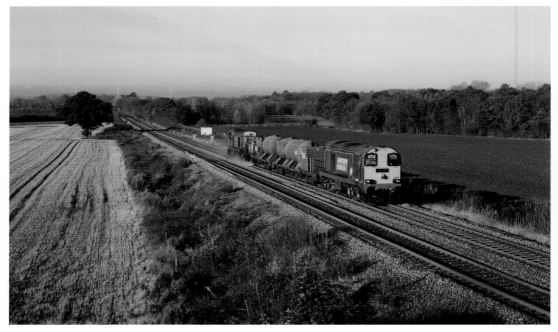

20303 begins to climb up and over the ECML at Tilts on 3S13 08.51 Wrenthorpe–Grimsby Town RHTT, 11 November 2016.

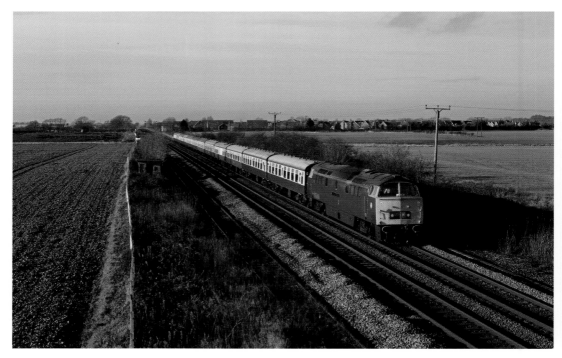

D1015 looks superb passing Welton on 1Z17 05.42 Swindon–Scarborough 'The Yuletide East Yorkshireman' charter, 17 December 2016.

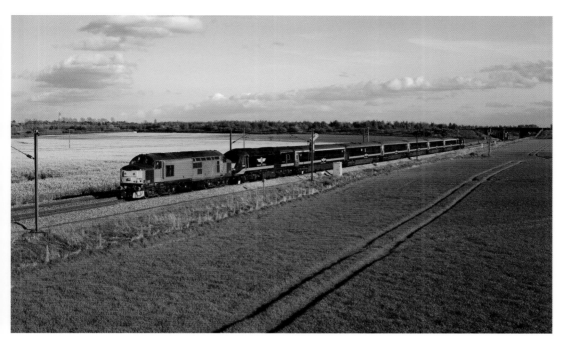

37800 drags a failed GC HST (lead by 43480) past Thorpe Willoughby on 5A12 13.44 Bounds Green–Heaton, 12 April 2017.

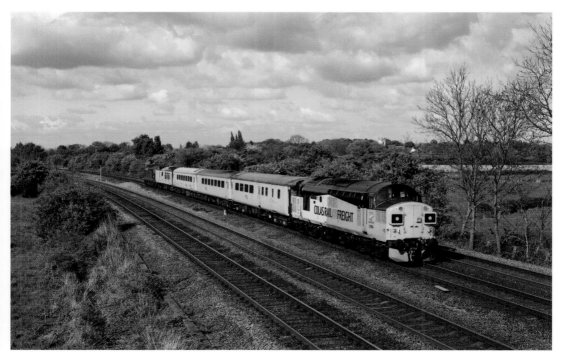

37099 passes Hillam gates on the rear of 1Q64 08.53 Derby RTC–Doncaster test train lead by 37057, 1 May 2017.

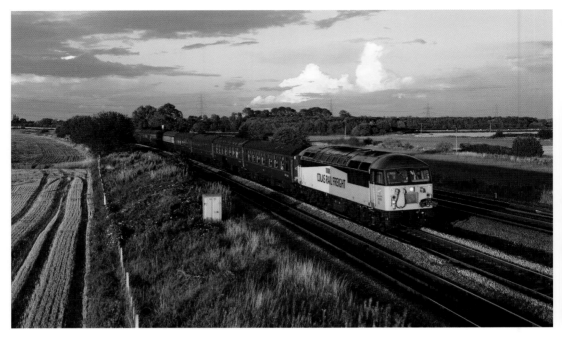

56302 passes Burton Salmon on 1Z27 17.15 Scarborough–Carnforth 'Spa Express', 31 August 2017.

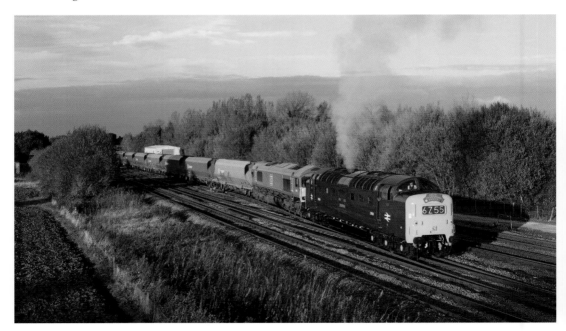

Not sure what to make of this working but the noise was superb. Alycidon has both engines on full and is doing about 5 mph – wow! 55009 with 66082 DIT crosses Milford Junction just after departure on 6Z55 15.32 Milford West Sidings–Neville Hill Up sidings stone hoppers, 29 October 2017.

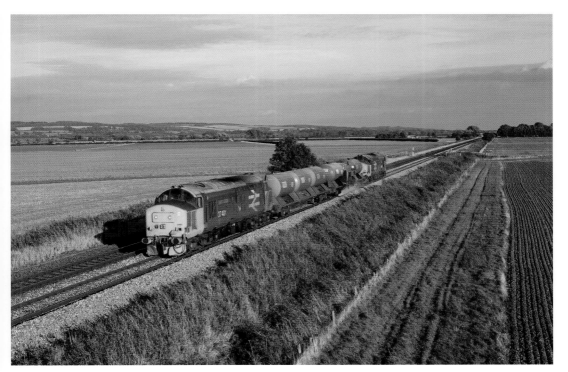

37402 (37401 on rear) near Cave crossing on 3J51 10.00 York Thrall–York Thrall RHTT, 8 October 2021.

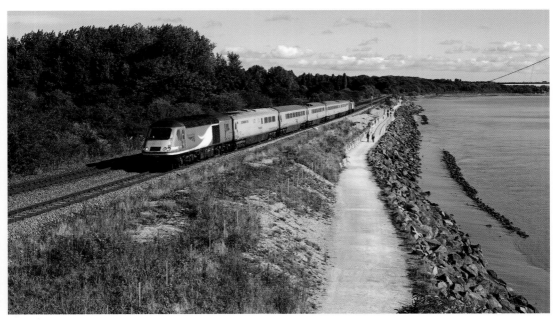

43299 passes along the foreshore at North Ferriby on 1Q35 12.25 Hull–Darlington Down Sidings NMT, 10 October 2021.

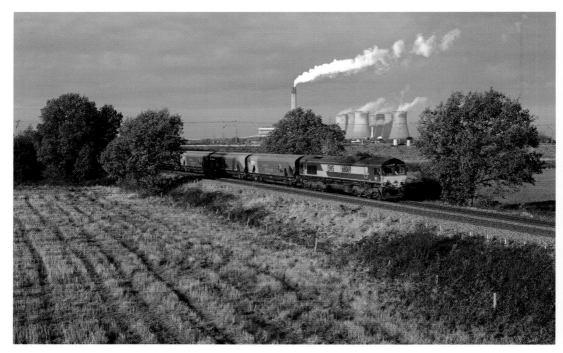

66069 passes Heck Ings on 6H62 08.15 Immingham–Drax PS biomass, 17 November 2017.

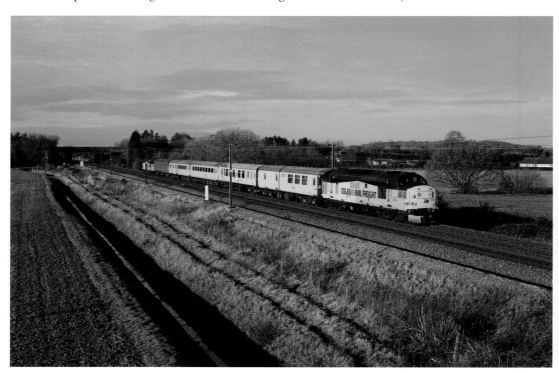

37175 passes Burn on 3Z01 10.00 Heaton–Derby RTC, 1 December 2017.

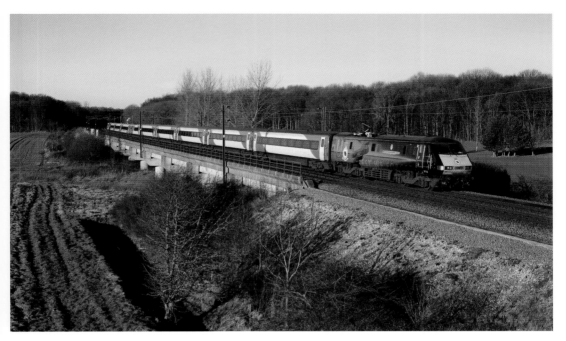

Running with the Class 91 on the south end due to Newcastle bridge engineering works, 91110 passes Bishop Wood on 1E11 10.27 Edinburgh–LKX, 7 January 2018.

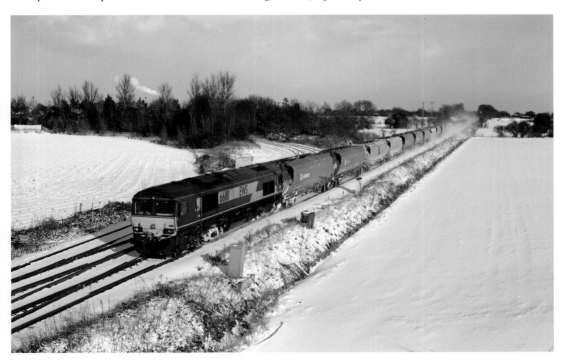

66110 passes Whitley Bridge Junction on 6D96 15.14 Drax PS–Milford Yard empty stone, 28 February 2018.

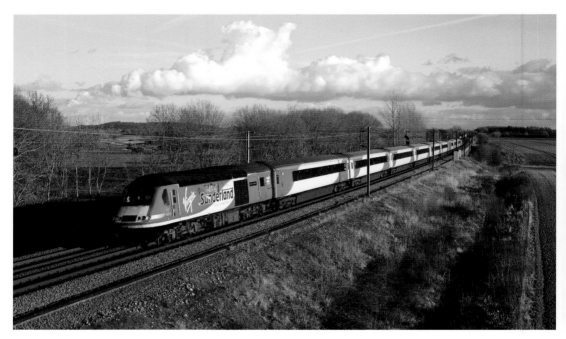

43274 passes Bishop Wood on 1S22 15.00 LKX–Stirling, 20 March 2018.

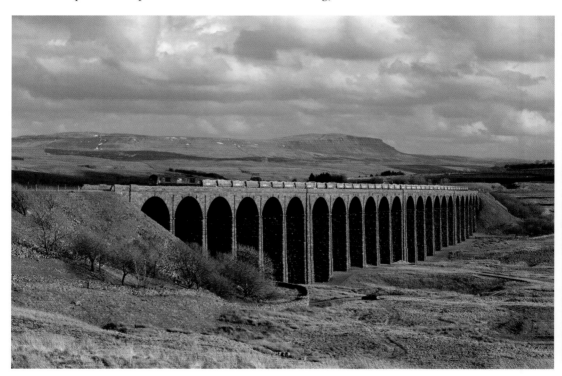

66303 crosses Ribblehead Viaduct on 6C89 09.38 Mountsorrel–Carlisle ballast working, 26 March 2018.

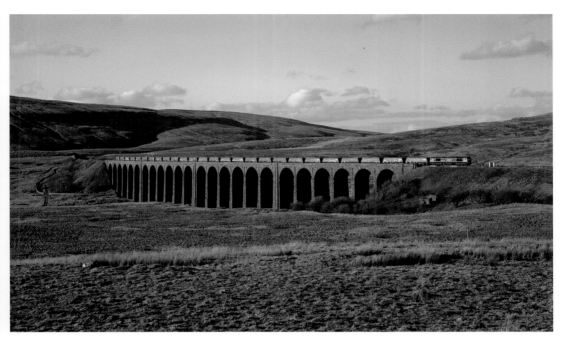

After running round at Blea Moor, 66762 crosses Ribblehead Viaduct for a second time on 6D77 16.43 Arcow Quarry–Leeds Hunslet stone, 26 March 2018.

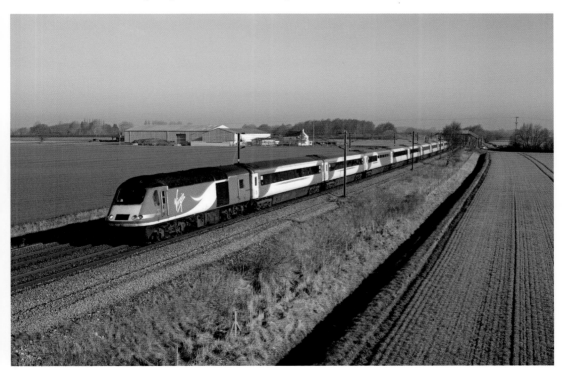

43311 passes Ryther Grange on 1E03 05.26 Stirling–LKX, 29 March 2018.

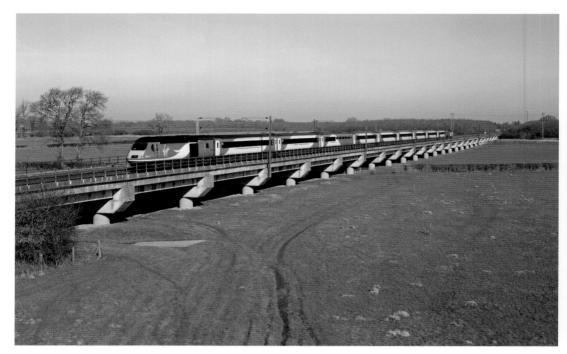

43314 crosses Ryther Viaduct on 1E05 07.30 Edinburgh–LKX, 29 March 2018.

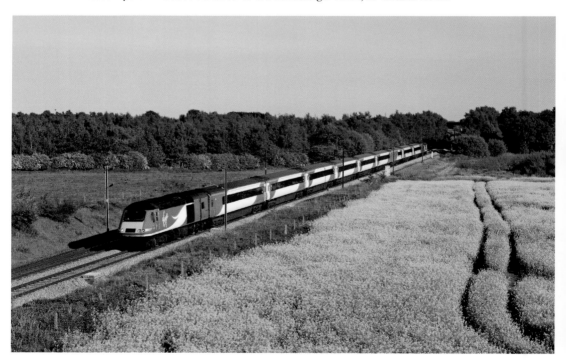

43295 passes the oil seed rape fields at Thorpe Willoughby on 1S24 16.00 LKX–Aberdeen, 14 May 2018.

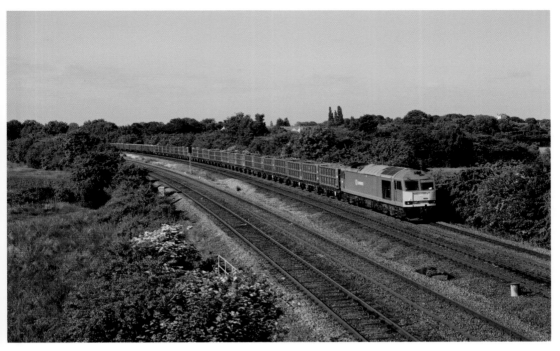

60054 nears Hillam Gates on 6Z15 14.11 Redcar–Scunthorpe, 7 June 2018.

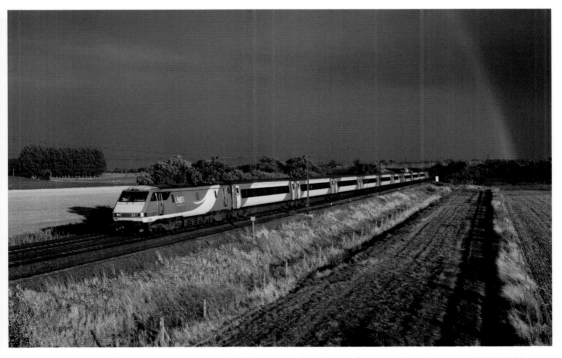

As the storm rolls away to the south 91129 runs under the rainbow passing Burn on 1S27 17.30 LKX–Edinburgh, 23 August 2018.

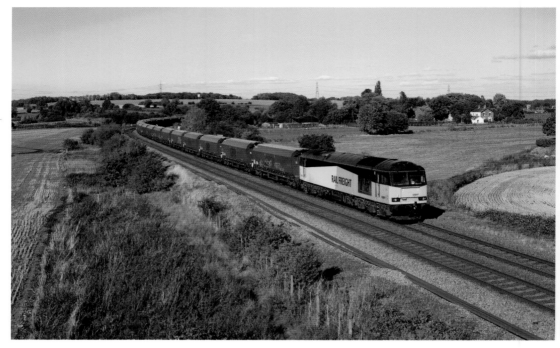

60047 passes Burton Lane on 6H70 12.24 Tyne Dock–Drax PS biomass, 28 September 2018.

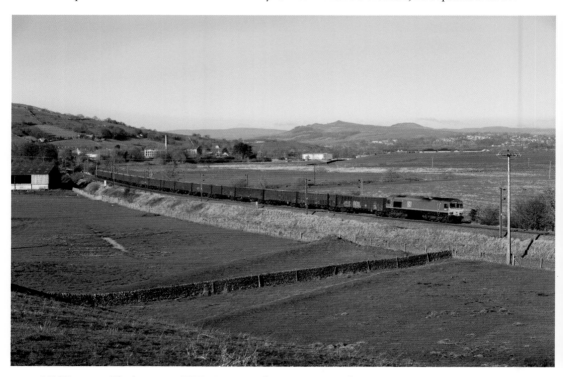

66027 passes Glusburn on 6E97 10.44 Newbiggin–Tees Dock gypsum, 17 January 2019.

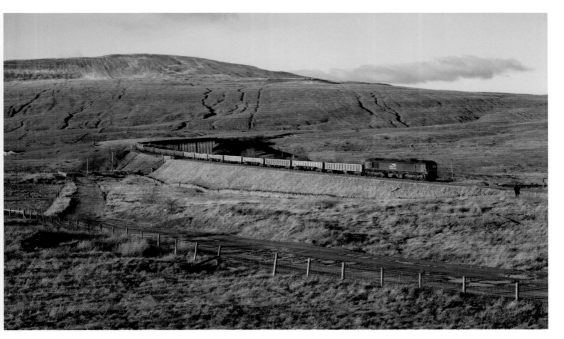

66304 catches the last of the winter sunlight as it nears Ribblehead on 6K05 12.46 Carlisle–Crewe BH engineers, 17 January 2019.

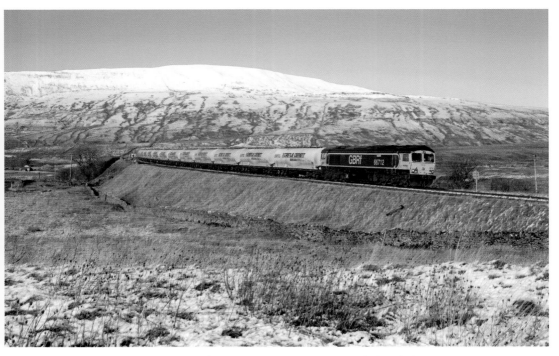

66712 nears a snowy Ribblehead station on 4M00 09.02 Carlisle–Clitheroe empty cement, 23 January 2019.

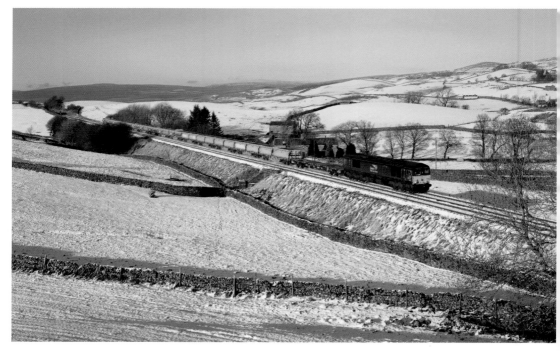

66425 nears Horton in Ribblesdale on 6K05 12.46 Carlisle–Crewe BH engineers, 23 January 2019.

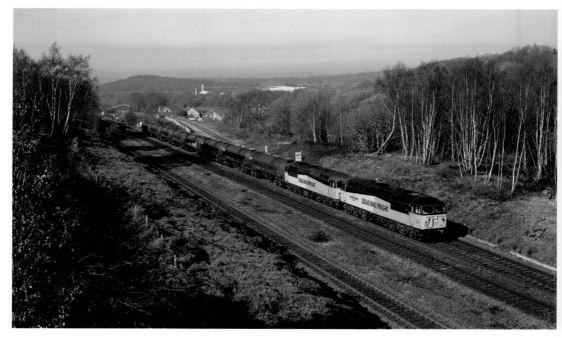

56049 and 56078 pass Heaton Lodge Junction on 6E32 10.02 Colas Ribble Rail (Preston Docks)–Lindsey empty bitumen tanks, 25 February 2019.

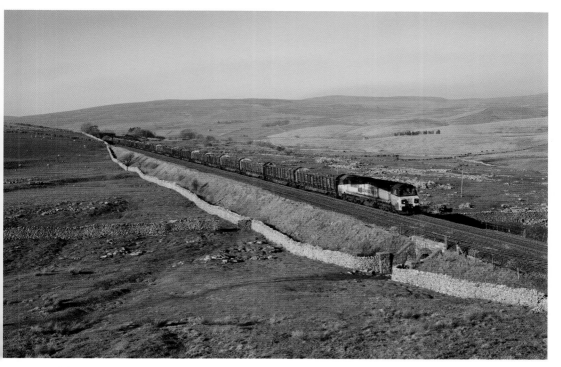

A grubby 70804 passes Selside Shaw on 6J37 12.58 Carlisle–Chirk logs, 26 February 2019.

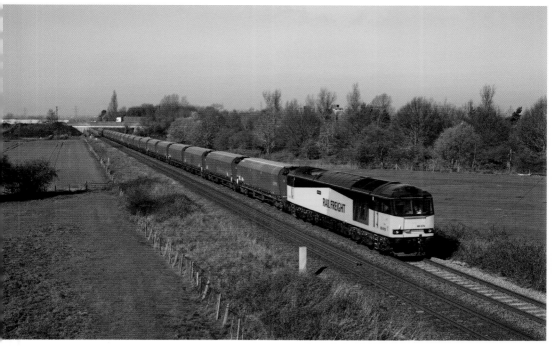

60076 passes High Eggborough on 6H12 06.24 Tyne Dock–Drax PS biomass, 29 March 2019.

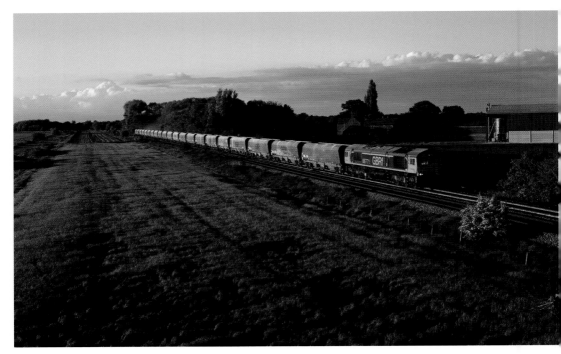

A high-summer-only working that I'm happy to have captured. 66771 passe Burn Airfield on 6M43 20.14 Selby Railfreight–Peak Forest empty stone, 21 May 2019.

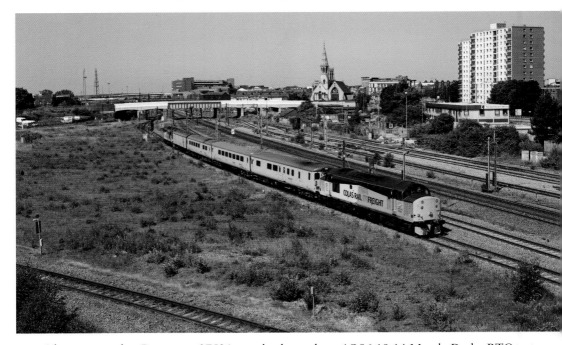

After a reversal at Doncaster 37521 now leads south on 1Q86 10.14 March–Derby RTC test train, 29 June 2019.

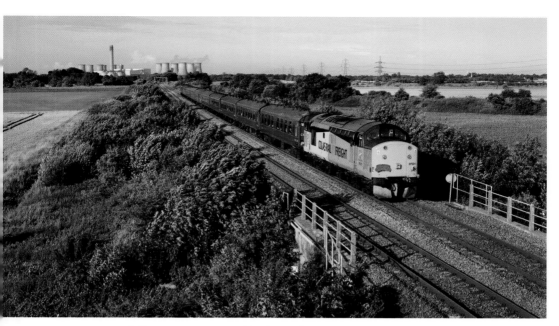

37521 passes Gowdall on 1Z40 17.05 Kellingley Colliery–Lancaster Branch Line Society's 'The Luca Pezzullo Express' charter, 20 July 2019.

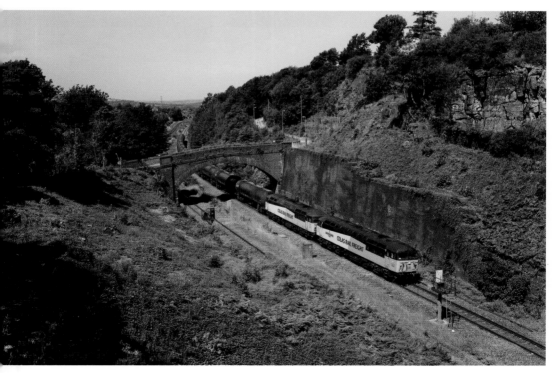

56049 and 56087 run through the recently cleared Horbury Cutting on 6E32 10.07 Colas Ribble Rail (Preston Docks)–Lindsey empty bitumen tanks, 25 July 2019.

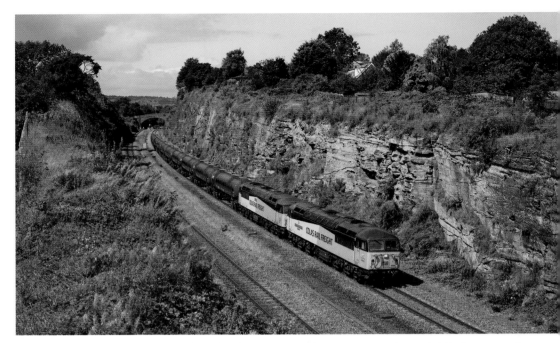

Amazing timing between the clouds. 56049 and 56302 pass through Horbury cutting approaching Slazengers bridge on 6E32 10.07 Colas Ribble Rail (Preston Docks)–Lindsey empty bitumen tanks, 15 August 2019.

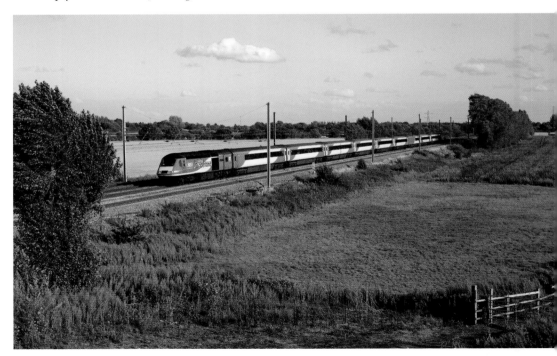

43274 passes Overton Grange on 1W24 16.00 LKX–Aberdeen, 19 August 2019.

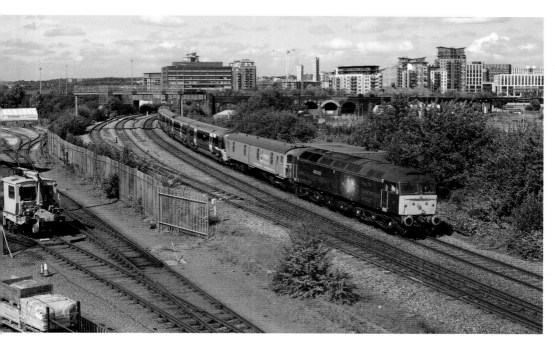

ROG-operated 47815 passes Leeds Holbeck on 5Q18 13.42 Neville Hill–Holbeck Sidings conveying a 332 unit for overhaul, 23 August 2019.

37521 crosses the River Don at Thorpe Marsh on 1Q64 08.52 Derby RTC–Doncaster West Yard test train, 26 August 2019.

37521 passes Milford Junction on 1Q64 08.52 Derby RTC–Doncaster West Yard test train, 26 August 2019.

Flying Scotsman-liveried 91101 nears Burn on 1S21 14.30 LKX–Edinburgh, 31 August 2019.

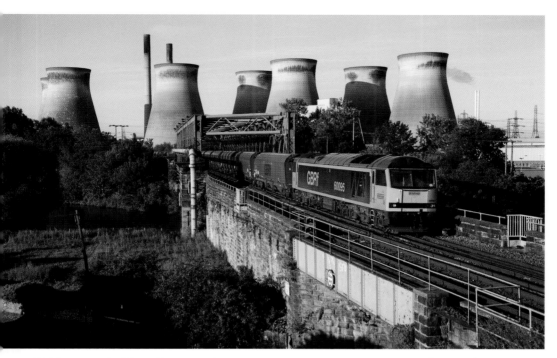

60095 crosses the River Aire at Brotherton on 6N45 07.30 Drax PS–Tyne Dock empty biomass, 5 September 2019.

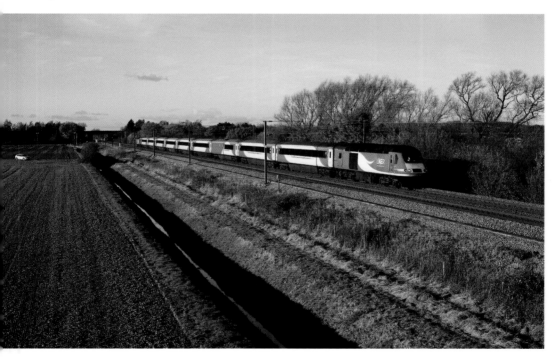

43296 heads south from Burn on 1E13 07.55 Inverness–LKX, 18 November 2019.

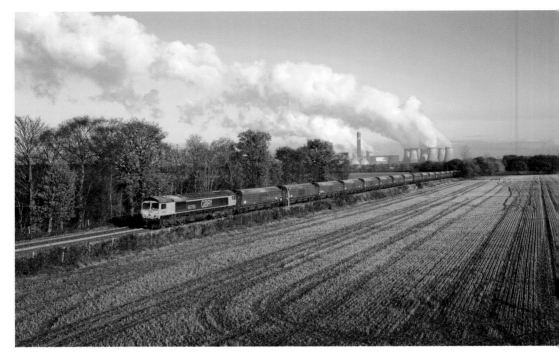

With the Drax power station complex dominating the skyline 66787 passes West Bank on 6N61 11.59 Drax PS–Tyne Dock empty biomass, 30 November 2019.

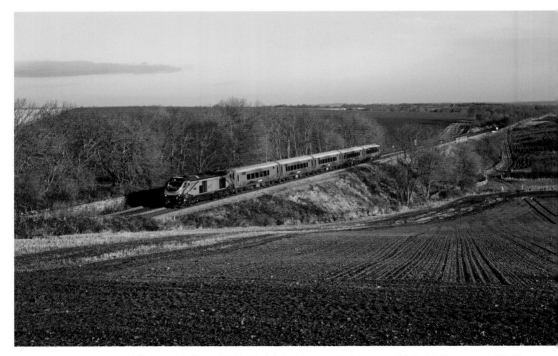

68022 passes Huddleston Hall on 1F60 09.41 Scarborough–Liverpool LS, 11 December 2019.

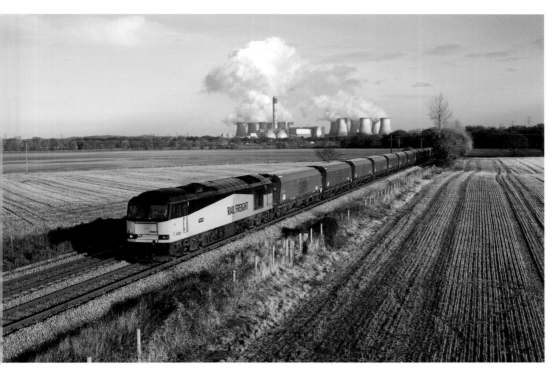

60002 nears West Bank on 6N61 12.00 Drax PS–Tyne Dock empty biomass, 11 December 2019.

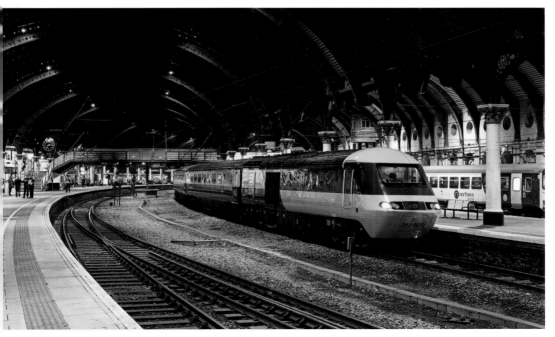

43112 (253003) stands at York's platform 5 on 5Z51 16.15 LKX–Edinburgh Craigentinny, part of the LNER HST farewell charter 'Let's Go Round Again', 21 December 2019.

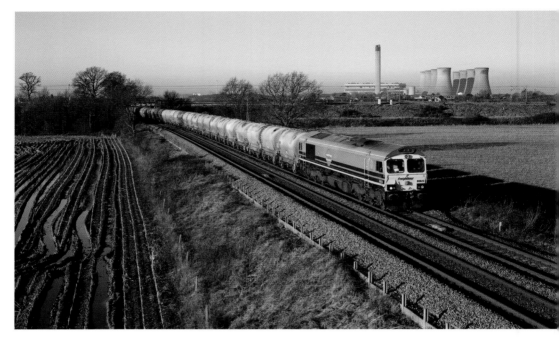

Carrying the new Freightliner orange and black livery, 66623 passes Heck Ings on 6E45 08.27 Hope Earles–Drax PS cement, 30 December 2019.

60040 passes Little Fenton on 6D11 13.19 Lackenby–Scunthorpe empty steel, 8 May 2020.

60040 passes Ulleskelf on 6N31 07.46 Lackenby–Scunthorpe steel, 30 May 2020.

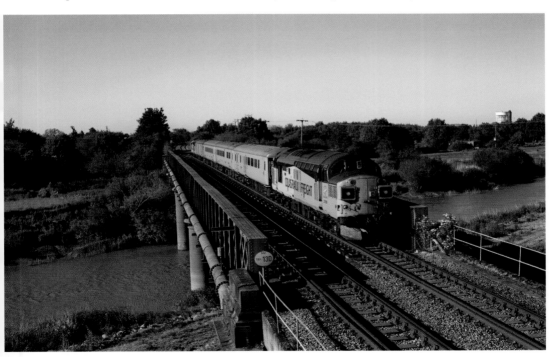

37099 crosses the Dutch river bridge, Goole, on 1Q47 15.13 Derby RTC–Derby RTC via Hull test train, 31 May 2020.

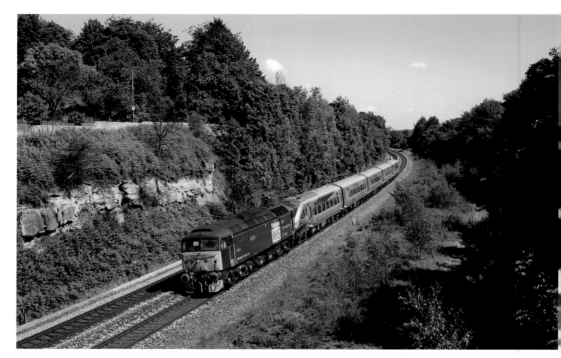

47813 passes Kilnhurst on 5Q32 10.16 Gascoigne Wood–Longsight dragging a TP mk5 set for storage, 1 June 2020.

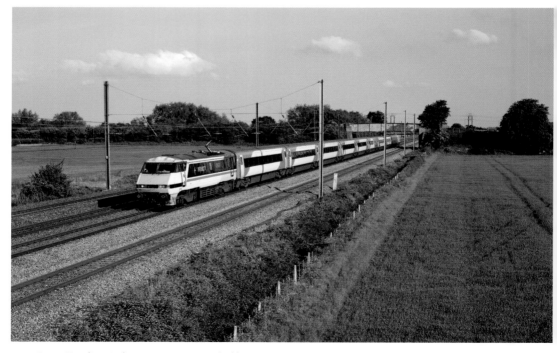

InterCity-liveried 91119 passes Raskelf on 1S25 16.30 LKX–Edinburgh, 13 June 2020.

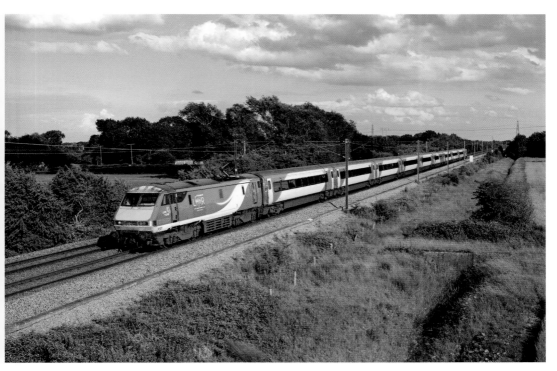

91121 passes Burn on 1S25 16.53 St Neots–Edinburgh, 20 June 2020.

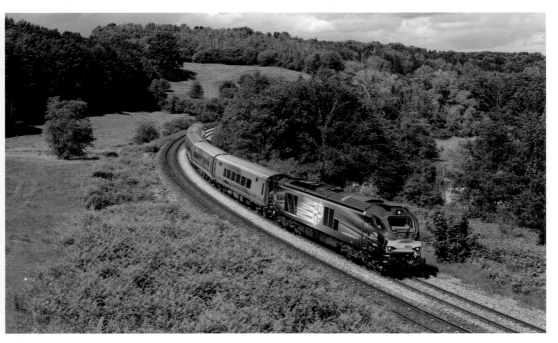

68034 rounds the 's' bends towards Kirkham Abbey on 1F70 14.34 Scarborough–Liverpool LS, 21 June 2020.

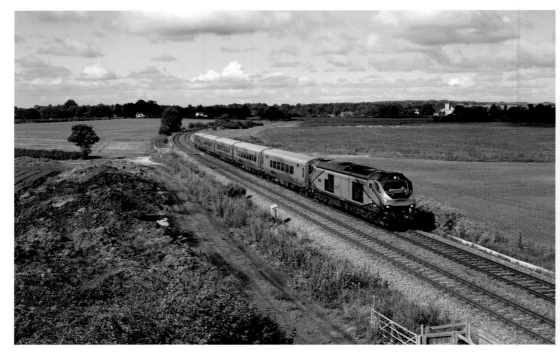

68032 heads away from Malton nearing the bypass on 1E25 06.54 Liverpool LS–Scarborough, 11 July 2020.

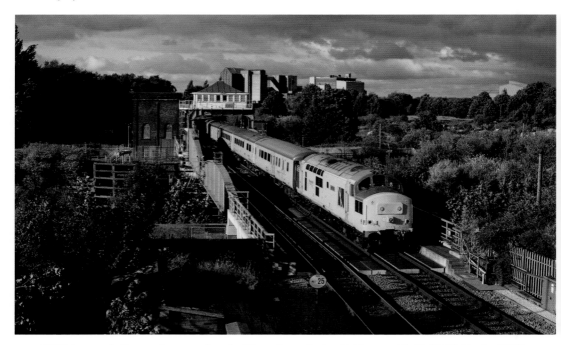

97304 nears Selby station crossing the River Ouse Swing Bridge on 1Q64 08.52 Derby RTC–Doncaster test train, 27 July 2020.

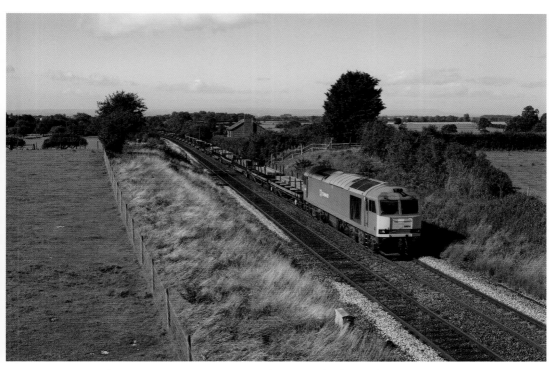

60054 passes Brompton on 6N31 07.46 Scunthorpe–Lackenby steel, 20 August 2020.

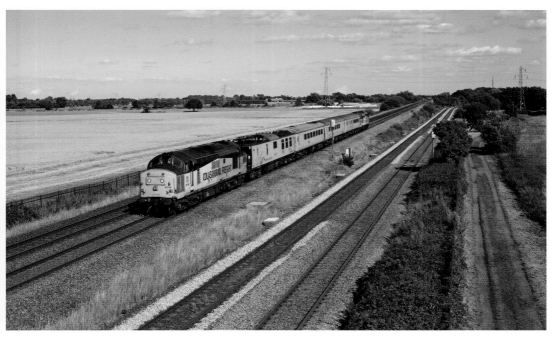

37175 and 37254 top-and-tail past Hambleton on 1Q64 08.52 Derby RTC–Doncaster CHS test train, 24 August 2020.

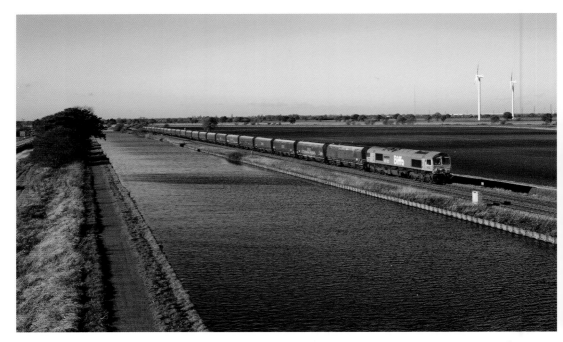

Biffa-liveried 66783 passes Maud's Bridge on 4R79 10.05 Doncaster Down Decoy–Immingham HIT empty coal, 13 November 2020.

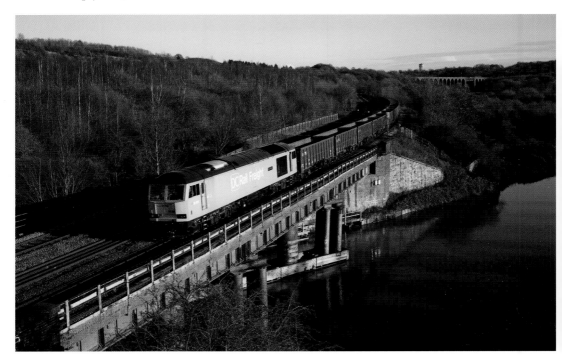

DCR-operated 60029 crosses the River Don at Connisborough on 6Z62 11.30 Rossington Colliery–Chaddesden Sidings, 5 December 2020.

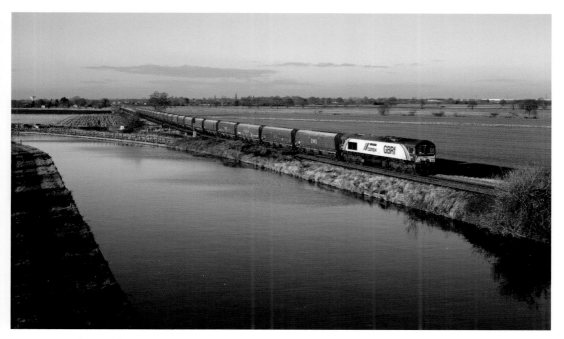

Cemex-liveried 66780 passes Maud's Bridge on 4R79 10.05 Doncaster Down Decoy–Immingham empty coal, 17 December 2020.

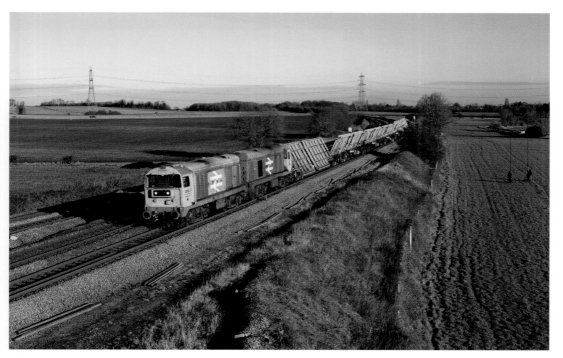

20132 and 20118 pass Burton Salmon on 6X20 10.45 York Thrall–Doncaster engineers, 17 December 2020.

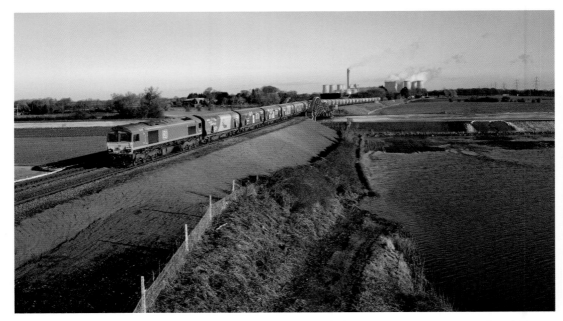

With flood water crossing the levy bank from the flooded River Aire, 66167 passes Gowdall Ings on 4R50 10.31 Drax PS–Immingham empty biomass, 22 January 2021.

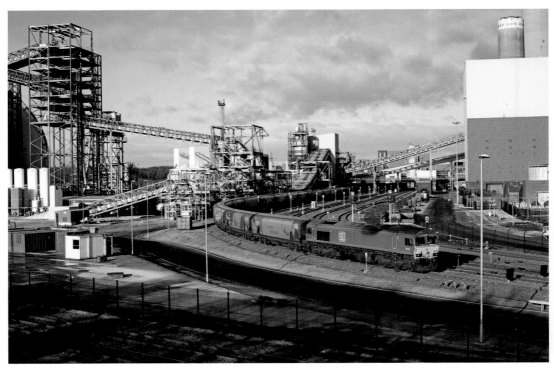

66167 stands inside the Drax Power Station complex awaiting departure on 4R53 14.33 Drax PS–Immingham empty biomass, 25 January 2021.

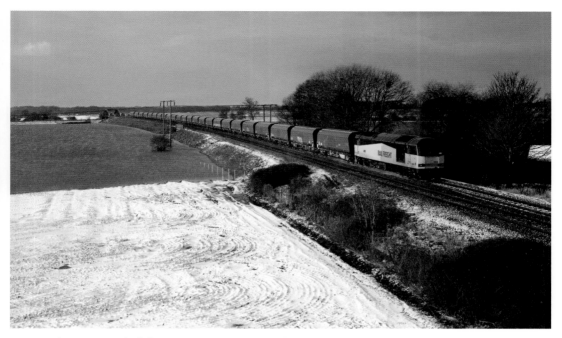

As the snow gently falls, 60096 passes West Bank on 6H12 06.33 Tyne Dock–Drax PS biomass, 9 February 2021.

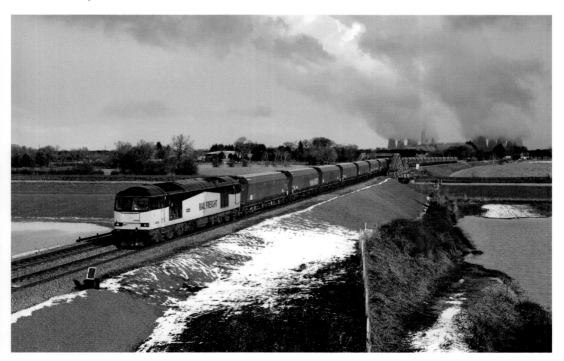

60096 passes Gowdall Ings on 6N61 12.00 Drax PS–Tyne Dock empty biomass, 9 February 2021.

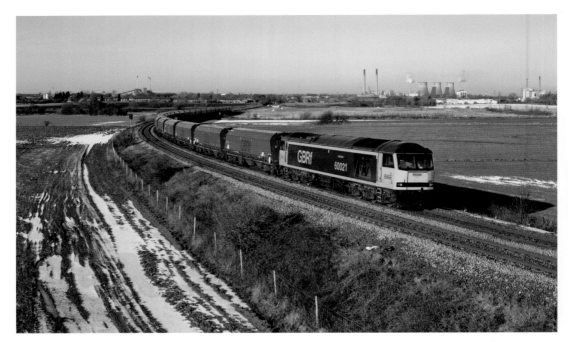

60021 heads away from Knottingley passing Blackburn Lane on 6H12 06.24 Tyne Dock–Drax PS biomass, 11 February 2021.

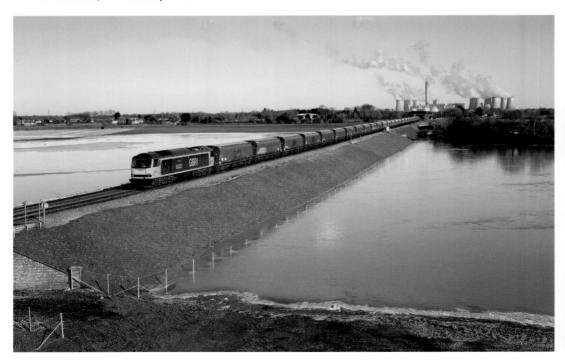

60021 passes a flooded Gowdall Ings on 6N61 12.00 Drax PS–Tyne Dock empty biomass, 11 February 2021.

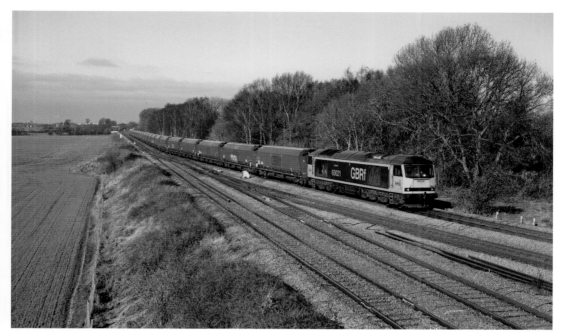

60021 crosses Drax Branch Junction on 6H12 06.24 Tyne Dock–Drax PS biomass, 27 February 2021.

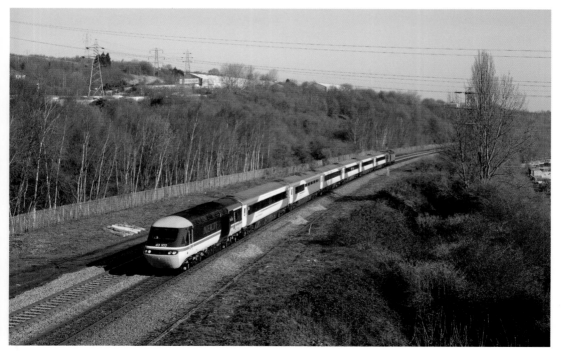

Celebrity 43102 passes Meadowhall on 5C43 10.19 Neville Hill–Sheffield ECS, 28 February 2021.

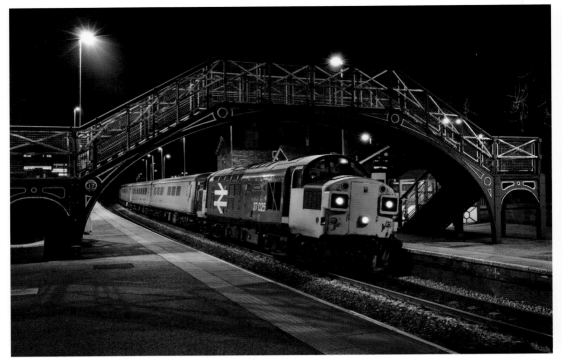

37025 pauses at Garforth station on 1Q75 22.45 Selby–Ilkley test train, 9 March 2021.

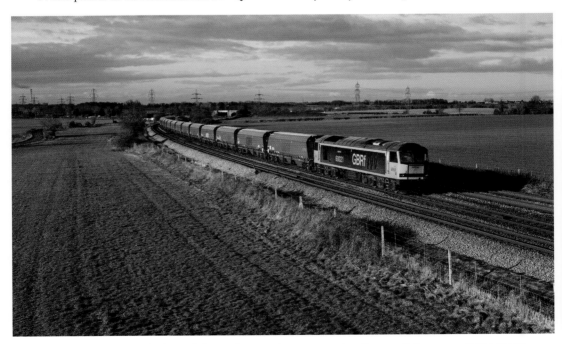

60021 just catches the last of the early morning sun passing Burton Salmon on 6N45 07.30 Drax PS–Tyne Dock biomass empties, 15 March 2021.

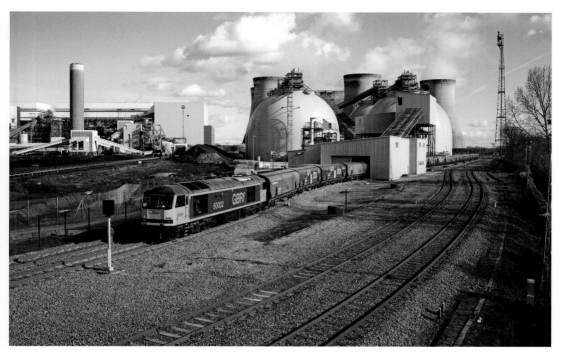

Freshly repainted 60002 passes through one of the three biomass unloading roads at Drax Power Station after arrival on 6E09 07.11 Liverpool Biomass TML–Drax PS biomass, 15 March 2021.

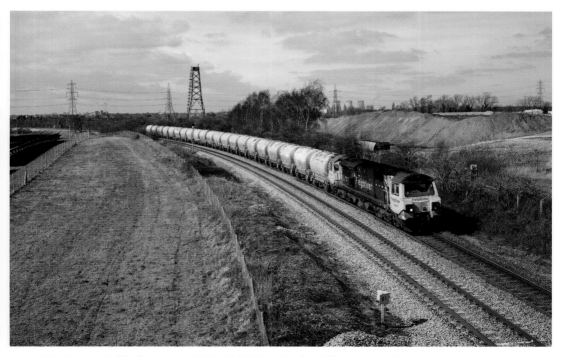

70010 nears Sudforth Lane on 6E45 08.27 Hope Earles Sidings–Drax PS cement, 22 March 2021.

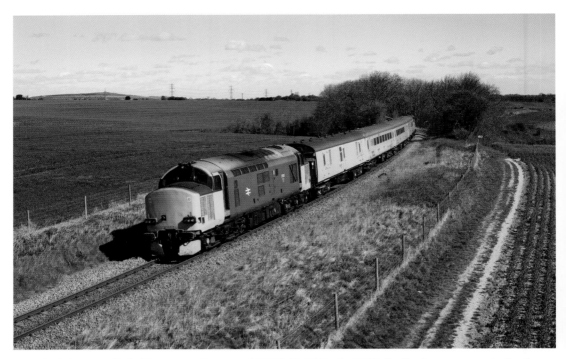

37610 passes Slade Hooton on the rear of 1Q60 08.52 Derby RTC–Barlby Loops test train (lead by 37254), 5 February 2021.

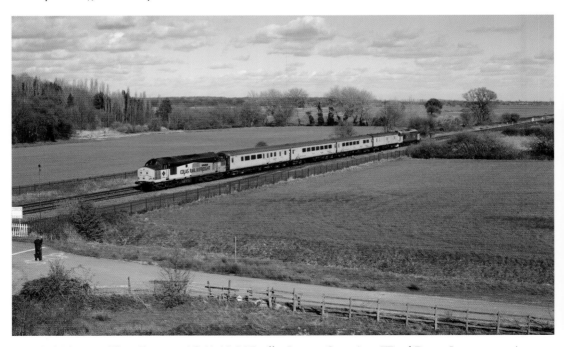

37254 passes Hagg Lane on 1Q61 15.36 Barlby Loops–Gascoigne Wood Down Loop test train, 5 April 2021.

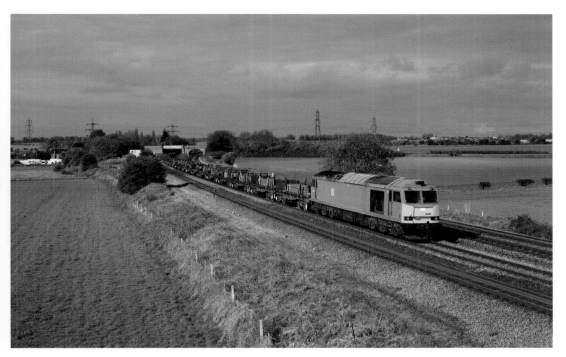

Under a threatening sky 60001 passes Burton Salmon on 6N31 07.47 Scunthorpe–Lackenby steel, 1 May 2021.

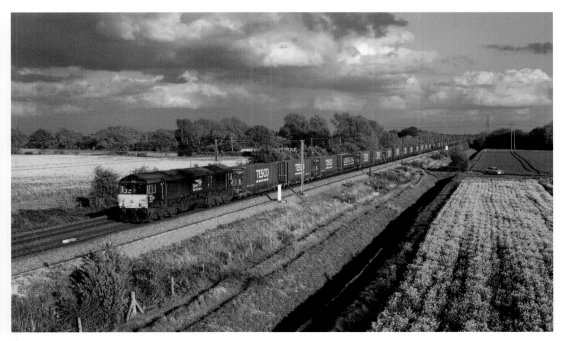

With the storm passing the east, 66424 passes Burn on 4N51 18.20 Doncaster IPORT–Tees Dock Tesco intermodal, 7 May 2021.

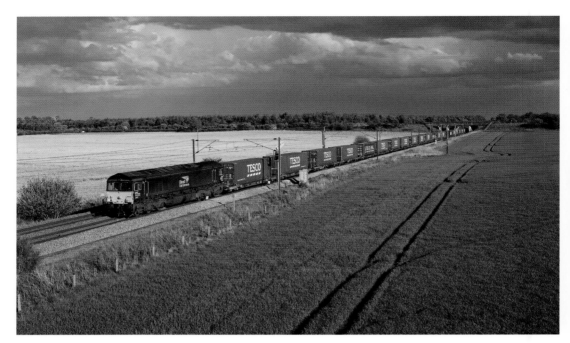

As the storm approaches 66424 passes Thorpe Willoughby on 4N51 18.20 Doncaster IPORT–Tees Dock Tesco intermodal, 18 May 2021.

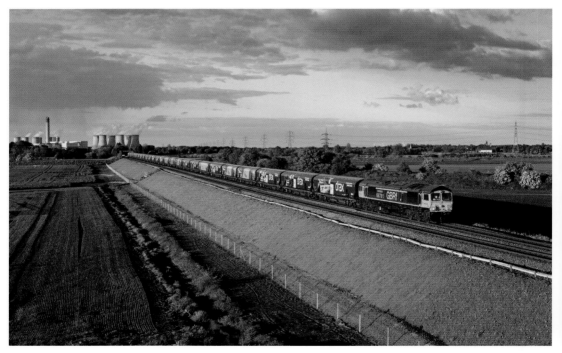

66761 catches the evening sun passing Gowdall Ings on 6M68 19.46 Drax PS–Liverpool Biomass TML empties, 19 May 2021.

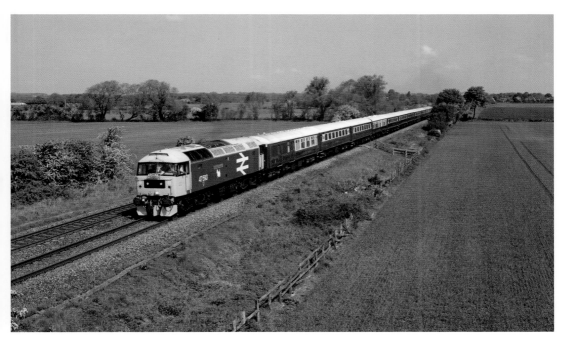

47593 looks the part passing Little Fenton on 1Z47 08.08 Newcastle–Appleby 'Statesman' charter, 29 May 2021.

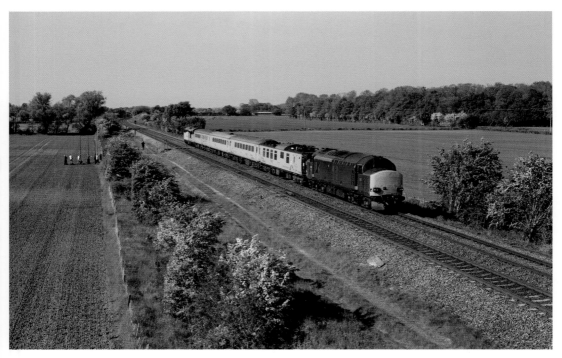

37612 passes the gallery at Little Fenton on 1Q61 15.36 Barlby Loops–Gascoigne Wood Down Siding test train, 31 May 2021.

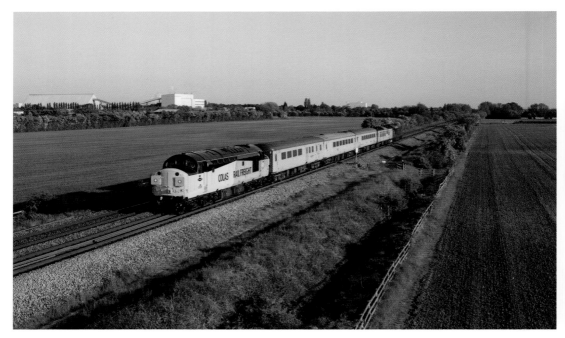

Fresh from overhaul and repaint into Colas livery, 37057 passes the gallery at Little Fenton on 1Q62 19.07 Gascoigne Wood Down Loop–Scarborough test train, 31 May 2021.

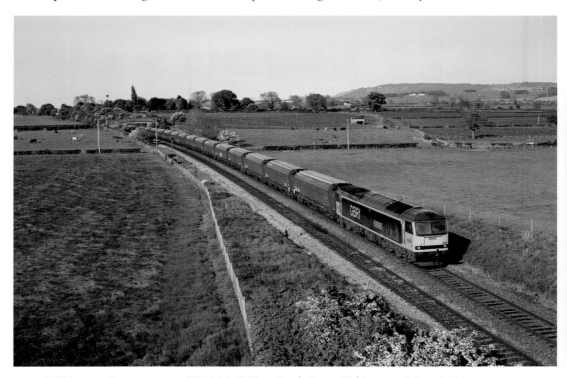

60095 passes Brompton on 6H55 16.49 Tyne Dock–Drax PS biomass, 1 June 2021.

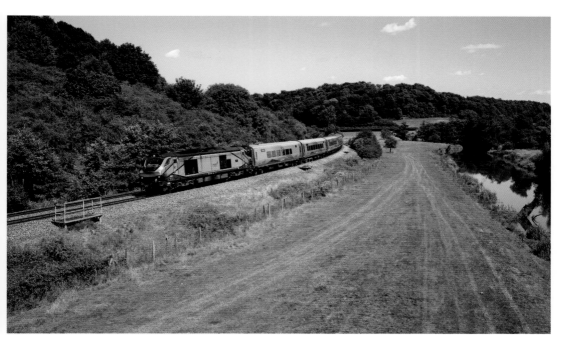

68031 rounds the curve past Huttons Bank Wood on 1T68 13.34 Scarborough–York, 17 July 2021.

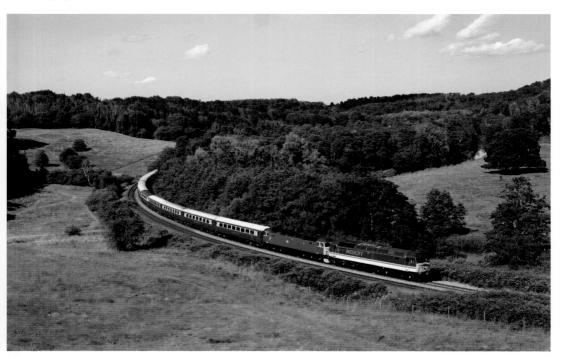

47828 and 47614 round the curve past Kirkham Abbey on 1Z88 15.50 Scarborough–Potters Bar 'Statesman' charter, 17 July 2021.

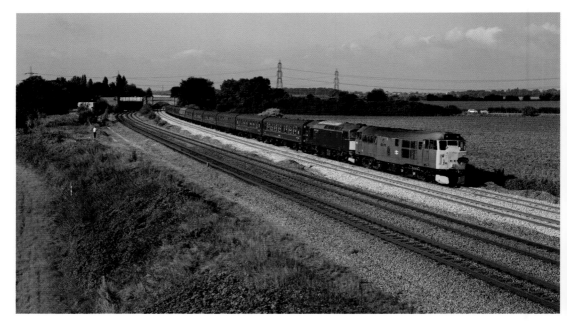

31128 and 33029 pass Burton Salmon on 1Z24 07.40 Carnforth–Scarborough 'Spa Express', 16 September 2021.

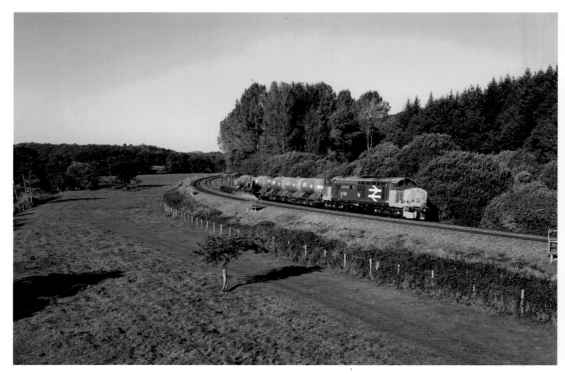

A nice and clean 37401 (37402 on rear) passes Huttons Ambo on 3J51 10.00 York Thrall York–Thrall RHTT, 21 October 2021.

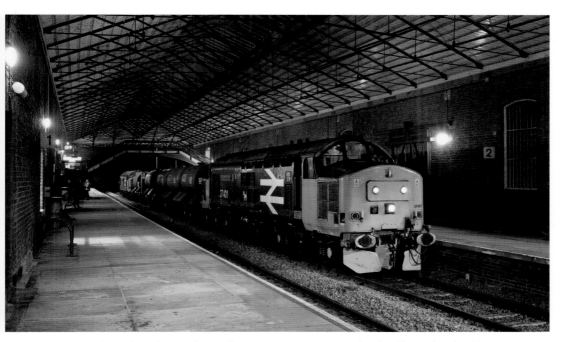

37401 stands under the roof at Filey on 3J51 10.00 York Thrall–York Thrall RHTT, 22 October 2021.

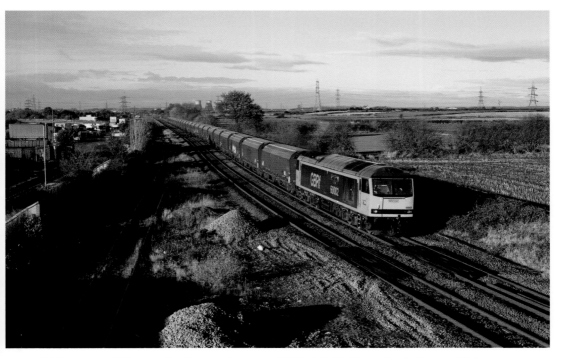

60002 passes Whitley Bridge station on 6H12 06.24 Tyne Dock–Drax PS biomass, 26 November 2021.

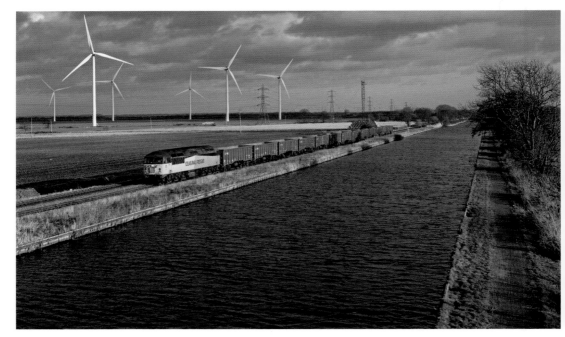

56094 runs along the canal near Maud's Bridge on 4C29 13.02 Barnetby Sidings–Doncaster Wood Yard empties, 3 January 2022.

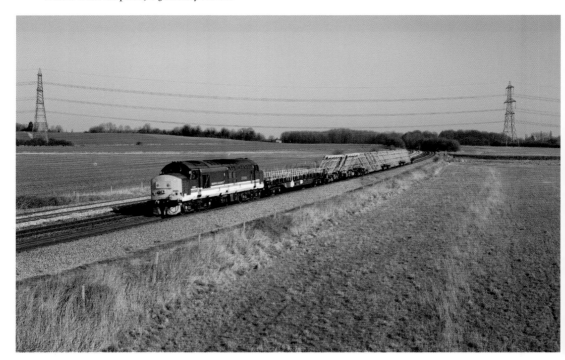

37425 passes the large gallery at Burton Salmon on 6X20 09.55 York Thrall–Doncaster Up Decoy engineers, 8 March 2022.